IMAGES of America
THE WHEATON FRANCISCAN HERITAGE

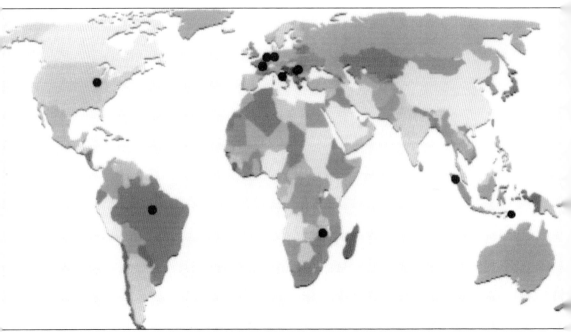

The Wheaton Franciscan sisters are part of an international congregation (Franciscan Sisters, Daughters of the Sacred Hearts of Jesus and Mary) with headquarters in Rome, Italy, and provinces in Germany, the Netherlands, Indonesia, the United States, and a sector in France. The sisters also minister in Romania, East Timor, Malawi, and Brazil. Dots on this world map indicate the sisters' global presence. (Courtesy of Franciscan Sisters, Salzkotten; adaptations by Robert Loizzi.)

On the cover: This photograph from September 1, 1924, shows a portion of the 20 novices, postulants, and sisters who arrived in St. Louis, Missouri, from Germany. Their arrival marked the end of a 17-year hiatus of German sisters coming to America. It was the largest group to come to this country at one time. The sisters seated in the front row were leaders in the American province. (Courtesy of St. Anthony's Medical Center.)

IMAGES
of America

THE WHEATON FRANCISCAN HERITAGE

Jeanne Guilfoyle

Copyright © 2009 by Jeanne Guilfoyle
ISBN 978-0-7385-6046-5

Published by Arcadia Publishing
Charleston, South Carolina

Printed in the United States of America

Library of Congress Control Number: 2009924690

For all general information contact Arcadia Publishing at:
Telephone 843-853-2070
Fax 843-853-0044
E-mail sales@arcadiapublishing.com
For customer service and orders:
Toll-Free 1-888-313-2665

Visit us on the Internet at www.arcadiapublishing.com

This book is dedicated to all Wheaton Franciscans, past and present, who incarnate the love and compassion of God.

Contents

Acknowledgments		6
Introduction		7
1.	Grounded in the Light	9
2.	Deepening a Commitment	23
3.	Rooted in the Gospel	33
4.	Faithful to Values	51
5.	Meeting the Needs of the Times	67
6.	Living Compassionately and Creatively	79
7.	Sharing Leadership in Ministry	91
8.	Continuing to Transform	101
9.	Integrating Contemplation and Action	113
Bibliography		126
Glossary		127

ACKNOWLEDGMENTS

This book grew out of love and admiration for the Wheaton Franciscans and a desire to share their remarkable history. From their foundress, Mother Clara Pfaender, to the sisters who have followed her call through the decades, these women have been and continue to be instruments of peace, transformation, hope, and healing. I apologize at the onset for those whose contributions have been omitted or distorted in any way. Difficult choices had to be made in telling the rich and varied history.

I have many people to thank, foremost among them Sr. Gabriele Uhlein: mentor, friend, and source. She has generously contributed to this project. I am grateful to Sr. Audrey Marie Rothweil, congregational historian, for orienting me to the archives while animating the history with remarkable stories. The creation of this book is possible because of Sr. Bernadette Kirn's outstanding contribution in establishing the Wheaton Franciscan archives.

The members of the book advisory committee have been the backbone of the project. Srs. Margaret Grempka, Mariette Kalbac, Shirley Krull, and Rose Mary Pint and covenant member Jeanne Connolly generously donated their time, talents, and energy. I am indebted to them for their careful editing, direction, and counsel. Patrick Connolly and Sr. Melanie Paradis have kindly provided their considerable time, insights, and recommendations.

Most images used for this book are the property of the archives of the Franciscan Sisters, Daughters of the Sacred Hearts of Jesus and Mary. Other photographs are appropriately credited.

I am grateful to my parents, Cal and Betty Guilfoyle, for their many gifts to me. Not least among them is their ability to relate historical information with such vibrancy that even the best fiction pales in comparison. Finally, I extend heartfelt gratitude and love to Srs. Lynn Schafer, Marge Zulaski, and Gabriele Uhlein for being "home" to me.

Through the grace of God I found my way to the Wheaton Franciscans and then discovered my life among them. I am honored to be their archivist and a covenant (nonvowed) member of the community. Current circumstances bring unique challenges to the community. May the wisdom and mercy gleaned from the past contribute inspiration and hope for the future.

INTRODUCTION

The Wheaton Franciscan sisters articulated their faith stance in a 2004 wisdom statement (the province's guiding tenet) in stating, "We face what life presents, returning only blessing that we may be instruments of peace, transformation, hope, and healing." A review of the rich history of the Wheaton Franciscans reveals the sisters have long lived by these principles. This guiding light has been at the core of the congregation since its inception.

The Wheaton Franciscans are the American province of an international congregation known as the Franciscan Sisters, Daughters of the Sacred Hearts of Jesus and Mary. The congregation was founded in Germany in 1860 by Mother Clara Pfaender under the guidance of Bishop Conrad Martin of Paderborn. Mother Clara set the tone of the congregational spirit in her writing of the founding constitution that emphasized mutual love and confirmed that "unusual times call for unusual actions."

As the congregation was growing, a movement started in Prussia to advance the separation of church from state and education institutions, known as the Kulturkampf. Eventually Falk Laws were imposed by the government on Catholic institutions, forcing congregations of women religious to seek alternative ventures. The regulations greatly restricted the influence and growth of the Catholic Church.

In the light of these restrictions, the Franciscan sisters moved outward to establish houses in both France and the Netherlands. In 1872, a parish priest from St. Louis wrote to his home parish in Paderborn, Germany, requesting German sisters to manage and staff a hospital for his parishioners of German descent. Bishop Martin approached Mother Clara with the request, and she gladly responded, facing what life presented. Suddenly the United States became a viable alternative for the sisters. Mother Clara asked for volunteers, and sisters stepped forth.

The sisters focused on living out God's love as commanded in scripture, "Love one another as I have loved you," by wholeheartedly devoting themselves to providing health care, education, and spiritual nurturing. The sisters "faced what life presented" in joining their efforts with thousands of other women religious as part of the pioneer church in America. During those early years of struggle to establish themselves in the United States, the sisters were visible instruments of peace, transformation, hope, and healing as they offered whatever they could from their own extreme poverty.

The sisters found themselves in a sea of uncertainty not uncommon to immigrants at that time. With a strong faith in the goodness of God, good humor, and endless hard work, the sisters made their way despite prejudice and bigotry. There were numerous times when the fragile new settlement of the Franciscan sisters in the United States almost came to an abrupt end. They confronted poverty, natural disasters, and an ocean that separated them from their motherhouse. It was during these years of isolation that the congregation experienced a crisis of leadership that further threatened a successful foundation in America.

With the sisters' strong belief in God and their courage in the face of obstacles, they let their actions speak for themselves. Soon their reputation for providing excellent care to those in their charge brought requests for their services. New sisters came from Germany to keep up with the demand. Young American women who came to know the sisters were eager to join them.

The sisters became active in a variety of ministries, chief among them health care, education, and, later, shelter. The sisters built, administered, and staffed numerous hospitals in the United States, primarily in the Midwest. The growth of the Franciscan sisters in the early 1900s was laudable. New hospitals were built in Missouri, Wisconsin, and Iowa. The sisters began ministries caring for orphaned children in Colorado and providing residences for young women in Illinois and Colorado.

All the provinces of the congregation enjoyed unprecedented growth and prominence. There was increased autonomy when the sisters in the United States became a province in 1884. In the 1920s, the sisters in France and the Netherlands became their own provinces. At an international meeting in 1920, the sisters decided that the congregation should pursue the recognition of papal right, meaning the congregation as a whole would be accountable to the Vatican and not to local bishops.

In the 1960s, Vatican II became a watershed time in the history of the Wheaton Franciscans, as it was for other religious congregations. Vatican II challenged the religious to return to the roots of their foundresses and founders and to refocus their ministry and lifestyle in light of the current times. As the church made substantial changes, the health care industry in the United States also underwent modernization and specialization. Again the sisters responded by being instruments of transformation and hope.

Lay partnership was always a cornerstone of the congregation. As the ministries became more complex and grew, the sisters asked themselves how their religious beliefs and principles could be shared with their partners who had varying beliefs of their own. Remaining passionate and committed to the mission and philosophy that had directed their work in the past, they sought a process of communicating that guiding force to lay leaders and staff. The sisters transformed the ministries by creating an innovative model of corporate sponsorship to articulate mission and philosophy, to monitor system development and influence, and to manage corporate effectiveness.

Today Wheaton Franciscan Services, Inc., continues to flourish as a Catholic not-for-profit organization with more than 100 health and shelter organizations in four states. Within this organization there is Franciscan Ministries, Inc., with approximately 2,800 units of affordable housing and assisted-living facilities in four states. In addition, Wheaton Franciscan Healthcare includes 15 hospitals as well as long-term care facilities, home health agencies, medical clinics, and physicians' offices. Since the 1980s, the sisters have been known for their commitment and leadership in justice and peace efforts, as well as involvement in spiritual development and the healing arts.

The Wheaton Franciscans themselves continue as a vibrant community with both religious and lay members committed to a gospel life of right relationship with all creation. At the province chapter in April 2008, community members adopted the following wisdom statement, incorporating their witness and commitment:

> Grounded in the light of the Gospel and our Franciscan way of life, we deepen our commitment through contemplation and action: To leadership in issues of justice, peace, and integrity of creation; To conscious use and sharing of resources that are faithful to our values of sustainability, solidarity, and collaboration; To live compassionately and creatively in the chaos and brokenness of the Church and the world; To grapple courageously with the challenges of the changing face of the province; To integrate the circle process as a respectful holding of one another and as a form of shared leadership. We face what life presents, returning only blessing, that we may be instruments of peace, transformation, hope, and healing.

One
GROUNDED IN THE LIGHT

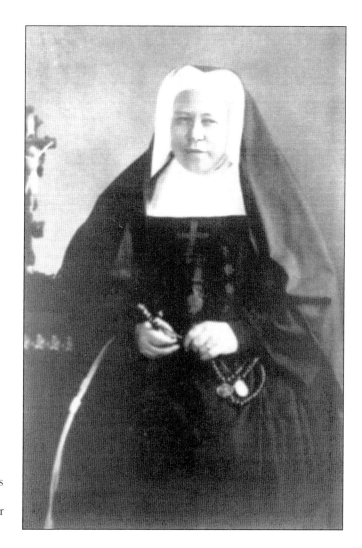

Welcome to the story of the Wheaton Franciscans. *The Wheaton Franciscan Heritage* begins with the foundress, Mother Clara Pfaender. This photograph of Mother Clara is the only one in existence. The date of the photograph is unknown. Her story, at first, may seem quite tragic, but her life has borne much fruit.

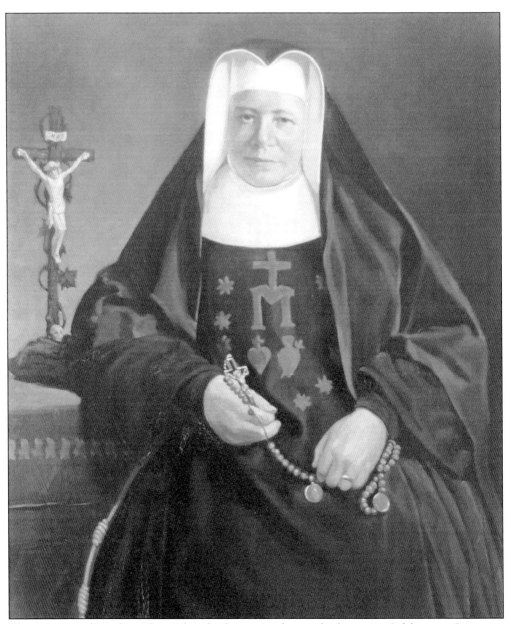

This portrait of Mother Clara Pfaender hangs in the motherhouse in Salzkotten, Germany, where the congregation developed. Born Theresia Pfaender on December 6, 1827, she was conscious at an early age of a longing for God. Even after she had become a vowed religious with the Sisters of Christian Charity, she sensed a deeper commitment within herself. Sister Clara wrote to the bishop of Paderborn, Germany, in September 1859, revealing a yearning to "live a life for the greater honor of God and the salvation of souls." Mother Clara founded the Franciscan Sisters, Daughters of the Sacred Hearts of Jesus and Mary in Olpe, Germany, in 1860. One of the hallmarks of Mother Clara's spirit was loving service to all. Women who were spiritually compatible joined her. Mother Clara wrote in the founding constitution that the sisters were to do "whatever charitable work the Lord gives them opportunity to perform in holy love." (Courtesy of Thomas Schmidt.)

Theresia Pfaender was christened at this font in St. Heribert's Church in Hallenberg, Germany. As a child, she lived her mother's Catholic faith. At age 12, she started instruction for her first communion. Her father was Lutheran and insisted she take instruction in his faith. After completing lessons, she made the choice for Catholicism. She wrote, "I came to learn the beauty of [Catholicism] and with clear conviction preferred it."

After completing her education, Theresia's father came to rely on the assistance of his eldest child in his mayoral office in Hallenberg (town pictured). Heinrich Pfaender trusted his daughter to skillfully draft complicated documents and to work effectively with businessmen. Although she was eager to do something more with her life, her business training and competence would later prove a great asset to the community she founded. (Courtesy of the City of Hallenberg.)

Theresia Pfaender had been an excellent student, and she desired with all her heart to teach. However, her father wanted her continued assistance. A friend of her father's, Rev. Anton Loeser, interceded. He advocated for Theresia to come to nearby Zueschen to assist in the rectory (left) and with parish activities at St. John the Baptist Catholic Church (right). In return, he would assist Theresia in her continuing education.

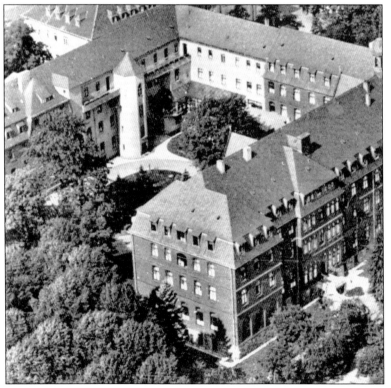

The desire to dedicate her life to God and to teach children had been growing in Theresia for years. By 1850, her father finally gave his consent for his eldest daughter to pursue her deepest wishes. Theresia met with the superior of the Sisters of Christian Charity in Paderborn (the convent pictured), a teaching order. It seemed a nearly perfect fit. (Courtesy of the Sisters of Christian Charity, Eastern Province.)

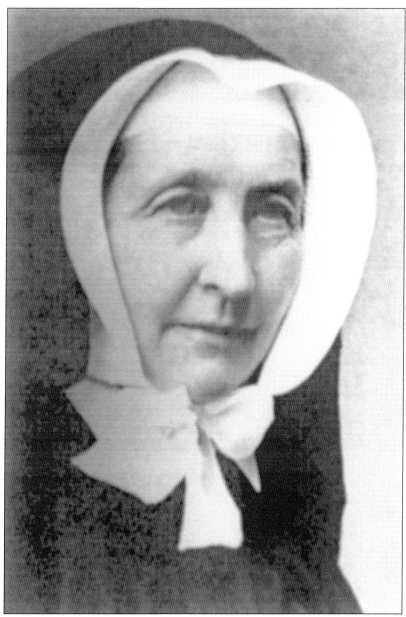

Mother Pauline von Mallinckrodt (pictured) was the superior of the Sisters of Christian Charity. At last, with a happy heart, Theresia Pfaender became Sister Clara. During the 1850s, Sister Clara excelled in teaching and in providing care to children in the order's orphanages. Sister Clara had further education and passed the state teachers' examinations in 1858. Mother Pauline and Sister Clara had a warm relationship. At one point Sister Clara became very ill and needed to be tended to by another sister in the community. Mother Pauline wrote to Sr. Mathilde Kothe, "I would be extremely happy if the dear Lord would preserve her for us since I love her very dearly. If, however, it pleases Him to establish a daughter house in heaven, I am willing for Him to take one of my dearly loved daughters; indeed, I have already offered Him this sacrifice from the bottom of my heart." Mother Pauline gave Sister Clara extraordinary counsel and guidance in discerning God's call. (Courtesy of the Sisters of Christian Charity, Eastern Province.)

After nine years, Sr. Clara Pfaender recognized a familiar tug at her heart. She longed to start her own congregation whose mission would be prayer for the church and service to the poor, orphaned, and sick. Sister Clara wrote to Bishop Conrad Martin of her desire. In this house in Olpe, Germany, she and two friends (Regina Loeser and Aline Bonzel) started their Franciscan life together, with Sister Clara as their leader.

Continuing the education and care of orphans, the sisters of the early community also tended to the sick in their homes. This ministry brought the sisters into conflict with another group of religious in Olpe who were engaged in home care. Bishop Martin urged Mother Clara to find a new home for her congregation. The growing community established this convent in Salzkotten, six miles from the diocesan seat of Paderborn.

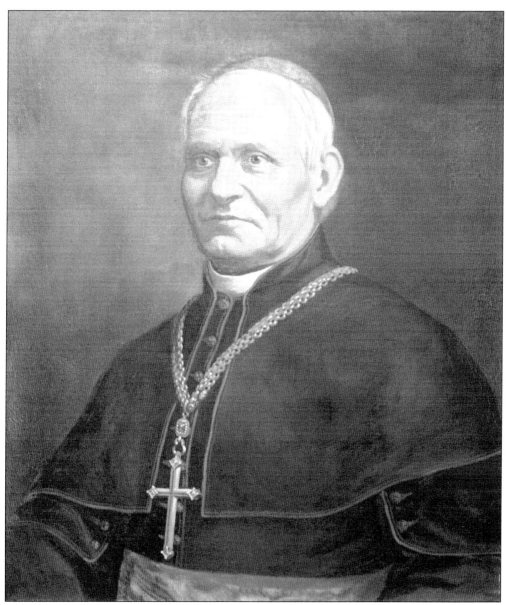

Bishop Conrad Martin was instrumental in the founding of the congregation of the Franciscan Sisters, Daughters of the Sacred Hearts of Jesus and Mary. It was his dream to have in his diocese sisters who followed the rule of St. Francis and were dedicated to praying for the church. When Sister Clara came to him with her intention, it was a marvelous synchronicity. Some years later, Bishop Martin found himself at odds with the Bismarck government of Prussia. He openly opposed the Kulturkampf, a set of cultural regulations that limited the influence of the Catholic Church. Among the regulations were policies that prohibited sisters from teaching children or managing orphanages. The policies also restricted the growth of congregations, and new members could not be admitted unless approved by the state. Motherhouses were put under great scrutiny and were subjected to unannounced inspections. Bishop Martin was imprisoned in 1874 because of his opposition to the policies. He later escaped prison and was exiled to Belgium, where he died in 1879. (Courtesy of Thomas Schmidt.)

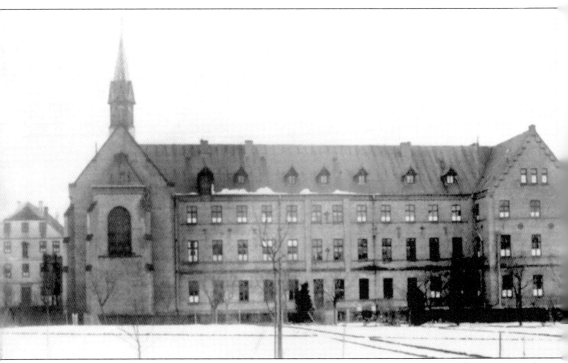

Despite increasing pressure from the government, the congregation continued to grow under Mother Clara Pfaender's unwavering leadership. She not only carried immense duties as general superior but also served as novice mistress and trained the postulants. She assisted in the care of orphaned children and joined her sisters on the battlefields of the Austro-Prussian War (1866). Indeed, the congregation's selfless service in the war was recognized by Queen Augusta of Prussia (1867). The sisters cared for the wounded in the Franco-Prussian War (1870–1871), and they were present during the cholera and typhoid epidemics that followed the war. As a result, their fine reputation carried far beyond Salzkotten, Germany. The sisters began mission houses in Germany, Holland, and France. Mother Clara made the bold decision to build a new motherhouse to meet the growing needs of the congregation. The motherhouse was completed in 1872 and remains the main headquarters for the German province today. This photograph is taken from the behind the motherhouse.

In 1875, Mother Clara visited Bishop Conrad Martin in prison. Bishop Martin handwrote a document for Mother Clara during her visit, outlining powers he was authorizing her to use during the time of governmental oppression. The powers he granted her were ordinarily reserved for clergy, and he urged judicious use of the powers in strict secrecy. The plenary powers became known in later years as the "Burning Seal" (pictured). It was discovered later that Mother Clara wore the document close to her heart at all times. Because Mother Clara found it necessary to utilize the powers in a handful of situations, she was questioned by church authorities and rejected by her own sisters. She never divulged the secret of the powers she was given by Bishop Martin, even after his death. In 1880, she was severely censored for her actions. She went to Rome to plead her case before Pope Leo XIII. Her pilgrimage to the Vatican would have heartbreaking consequences. The actual document containing these powers was not found until almost a century after her death.

This cross stood on Mother Clara Pfaender's desk day and night. During the dark days of the Kulturkampf in the 1870s, she had to make difficult decisions to provide for new members, to help her overworked sisters, and to serve those in need. In a Lenten letter, Mother Clara wrote, "Let us therefore be true cross-bearers, for then we shall also be given the palm of eternal life."

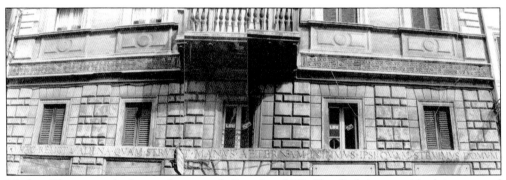

Mother Clara never had an audience with Pope Leo XIII. She died, impoverished, in a rented room in this building in Rome, exiled from her sisters and the ministry she loved. A Latin inscription on the building (pictured) still reads, "When in a short time we leave this house / that others' hands have built for us, / we shall enter an everlasting house / that we have built with our own hands."

In 1970, Salvatorian fathers in Rome came across a notebook belonging to the Franciscan sisters. They contacted the general directress, Mother Aristilde Flake, who was stunned to discover it was the original constitution, complete with handwritten corrections in the hand of Mother Clara and Bishop Martin. The photograph to the right shows Bishop Martin's approval and signature on the document. Seven years later, the Burning Seal and other crucial documents of Mother Clara's two years in Rome were found in the archives of Campo Santo Teutonico (a German seminary and pilgrim hostel located next to St. Peter's Basilica in Vatican City). The photograph below shows a pharmacy bill from shortly before her death in 1882. The medications suggest she had acute diphtheria, complicated by severe pain and difficulty breathing.

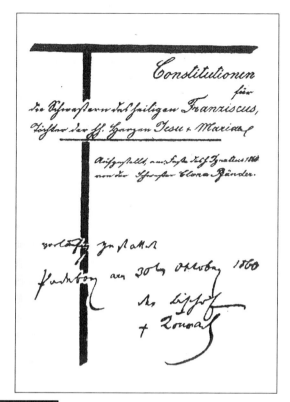

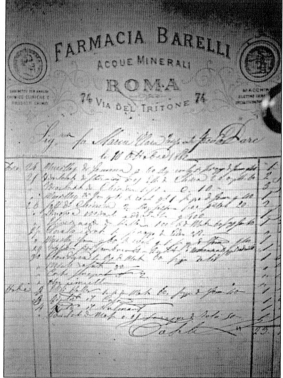

Despite travel challenges, the sisters visited various provinces. The visits would later include a pilgrimage to Mother Clara Pfaender's grave in Rome. The image to the left shows Sr. Carola Briedenbach in a "Kaiser Kutche" in 1949. This mode of transportation carried travelers from the train station in Salzkotten, Germany, to their destination. The photograph below, taken in 1960, portrays an international group of sisters at the cross marking the common grave. Second from right is Mother Florina Kloep, provincial directress of America's province from 1948 to 1960. She supervised the building of a generalate for the congregation in Rome and was the first American elected to the general council. During these years, Mother Florina and Sr. Brunilde Probst, of the German province, researched Mother Clara's life. Sister Brunilde authored the first book about Mother Clara, titled *The Burning Seal*, in 1960.

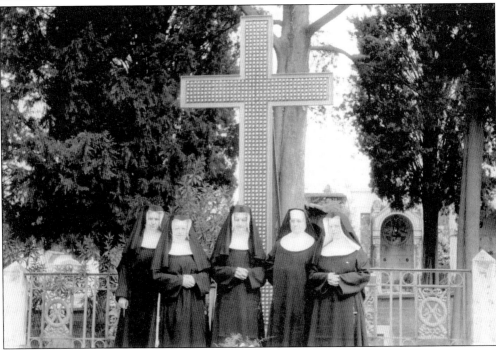

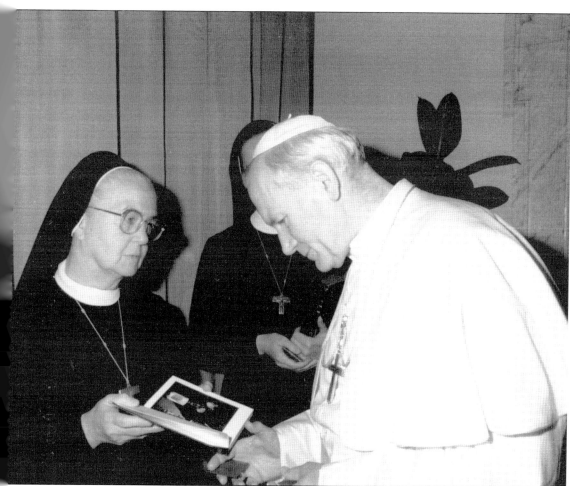

Mother Aristilde Flake dedicated herself to a vigorous study of Mother Clara Pfaender and to the education of the congregational members regarding her findings. She wrote *Light into the Darkness*, revealing the new information unearthed about Mother Clara. In 1982, on the occasion of the 100th anniversary of Mother Clara's death, Mother Aristilde presented a copy of her book to Pope John Paul II (pictured). Mother Clara, having never been granted the audience she sought with Pope Leo XIII, was presented, posthumously, to one of his successors. Mother Aristilde was the general directress of the congregation from 1966 to 1979, guiding it through the sweeping changes of Vatican II. As Mother Aristilde wrote in the foreword to the book, "In the providence of God we have been given an insight into the life of our foundress and to the charism of our Congregation. Certainly it is not a mere accident that this has occurred at a time when the Church is encouraging us to return to the wellspring of our Community." (Courtesy of Servizio Fotografico, L'Osservatore Romano.)

This is a picture taken in 1995 of one of the many pilgrimages that take place to Campo Verano in Rome where Mother Clara Pfaender is buried in a common pauper's grave. Today her daughters regularly come from around the world to remember her and celebrate her life. Her international congregation serves in Germany, France, Holland, Indonesia, and the United States, keeping Mother Clara's spirit of love and service alive. Additional missions in Brazil, Romania, East Timor, and Malawi minister to those in need with a wide variety of services. The service is always guided by the desire to meet the needs of the times. The sisters in Germany, Holland, and the United States are joined by associates who resonate with the charism and ministries. Mother Clara's parting words upon leaving the motherhouse in Salzkotten, Germany, proved prophetic: "I must perish; but the congregation will remain." Indeed, the congregation has remained and flourished following Mother Clara's charge: "No manner of loving service shall be excluded from their loving concern."

Two
Deepening a Commitment

The Sacred Hearts of Jesus and Mary were inspirational to Mother Clara Pfaender and continued to be a source of encouragement to the pioneer sisters in America. These hearts still call in love all who follow in Mother Clara's footsteps. This design of the sacred hearts around the tau cross (a traditional symbol of Franciscans) was rendered by Sr. Jane Madejczyk. The tapestry was sewn by Sr. Mary Paul Micka.

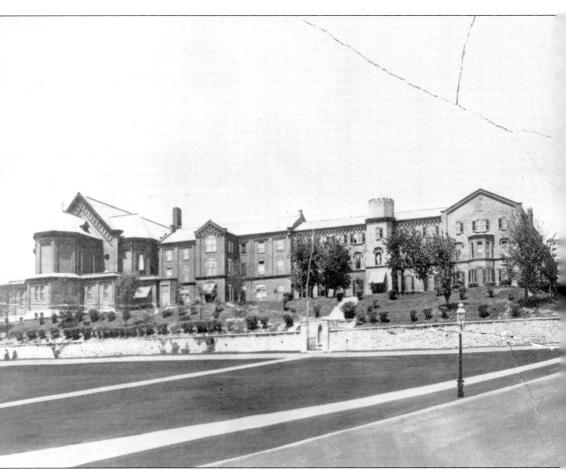

Mother Clara Pfaender was eager to explore new opportunities for her sisters because of the harsh consequences of the Kulturkampf. Catholic citizens from Germany immigrated to the United States in large numbers, as they also experienced persecution. Many settled in the St. Louis area. Demand for social services, particularly health care and education, increased with the swelling population. A request came to Bishop Conrad Martin from a German-born pastor at St. Boniface Parish in south St. Louis for sisters to begin a hospital for his parishioners. When Bishop Martin approached Mother Clara with the request, she immediately welcomed it. Finally a door was opening for her daughters who longed to serve God but were being denied that opportunity in their homeland. Three sisters volunteered to journey into the unknown to fulfill the appeal. The sisters arrived in December 1872 to find the hospital still under construction. They were taken to the motherhouse of the Sisters of St. Joseph of Carondelet, pictured here. This motherhouse stands today, much as it was then. (Courtesy of the Sisters of St. Joseph of Carondelet.)

The sisters found generous hospitality with the Sisters of St. Joseph, but they had little time to enjoy their new surroundings. Funds were needed to support the construction of the hospital, so the sisters set out on begging tours. With the money raised, St. Boniface Hospital was built and dedicated in September 1873 (sketch of hospital pictured).

Another early request for sisters came from Fr. Joseph Schmidt, pastor of St. Mary's Church in Cape Girardeau, Missouri, 125 miles south of St. Louis on the Mississippi River. Father Schmidt, familiar with the sisters' fine work in St. Louis, wanted sisters to provide medical care for his parishioners. He rented a house in 1875 as the first hospital. Three years later, the sisters purchased land and built this house. (Courtesy of the Southeast Missouri Archives.)

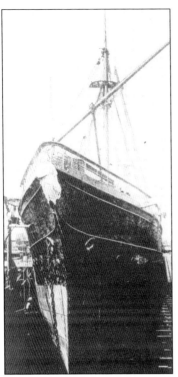

Sisters continued to come to America to serve. This steamer, the *Weser*, brought five Franciscan sisters to the United States in the autumn of 1875. By that time, there were 21 sisters who had journeyed across the ocean to commit their lives to the ongoing work of the congregation. The sisters answered requests for hospital work and to educate children in German parish schools. (Courtesy of the Peabody Essex Museum.)

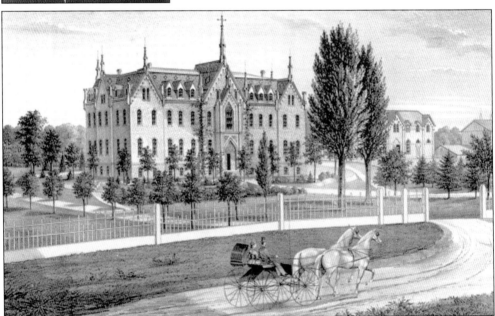

Requests for the sisters' services came from far and near. In 1875, Fr. Theodore Bruenner of Pio Nono College (pictured) in St. Francis, Wisconsin, requested sisters for household duties at the school. The sisters' responsibilities ranged from cooking, laundry, and housekeeping to outdoor work, involving heavy labor. An appeal for sisters to teach at Immaculate Conception Parish in Arnold, Missouri, was also answered by the sisters. (Courtesy of the David Rumsey map collection.)

Sr. Longina Sommer (left) and Sr. Theodora Brockmann were among the first Franciscan sisters to come to the United States and the first to celebrate their golden religious jubilee in this country (occasion of photograph). Sister Theodora wrote a history of the province and was an eyewitness to many of the events about which she wrote. In her book, Sister Theodora wrote, "It was charity that endeared them to all who came in contact with them and their work was lauded in St. Louis and beyond." Sister Theodora documented the dire poverty of the sisters. When they were invited to minister in a new area, they went with only the clothes they were wearing. They depended on divine providence for all their needs. News of the sisters' kind and loving service spread quickly wherever they ministered. Their acts of selflessness during times of local crises were rewarded with kind neighborliness, which gradually brought feelings of home to the sisters. Donations of furniture, freshly baked bread, fruits, and vegetables sustained the faith-filled sisters and their missions.

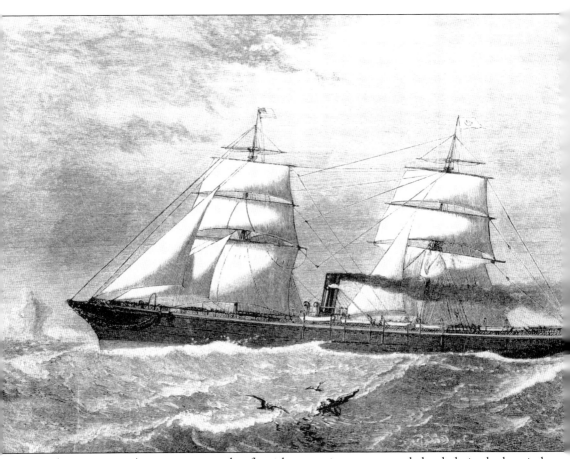

As missions in America continued to flourish, more sisters were needed to help in the hospitals and parish schools. During this time, leadership proved to be a challenge for Mother Clara Pfaender, especially from across the ocean. Adding to the difficulties of time and distance were differences in language and culture. Mother Clara knew that in time the United States would be its own province. In late 1875, plans were in place to send the third group of sisters that year to St. Louis. Mother Clara decided the moment was right to establish the groundwork for a province by sending a sister to lead the community in the United States. She put her faith in 28-year-old Sr. Henrica Fassbender. Sister Henrica, along with Sr. Barbara Hueltenschmidt, Sr. Brigitta Damhorst, Sr. Norberta Reinkober, and Sr. Aurea Badziura, set sail for America in December 1875 on the *Deutschland* (pictured). (Courtesy of the Peabody Essex Museum.)

Before leaving for her leadership assignment in the United States, Sister Henrica wrote a letter to Mother Clara that reflected their trusted friendship. Both anticipated the separation would be difficult. The poem expressed Sister Henrica's ambivalence about leaving. The first stanza (pictured) states, "Now the solemn hour of departure is at hand, / And my heart, deeply touched, throbs with fear; / 'Tis bleeding as though pierced by many a spear, / For in bitter pain we leave you and your land so dear." The poem is signed, "Dedicated to our dearly beloved Venerable Mother at our departure for America by Your loving daughter, grateful unto death, Sister M. Henrica, Salzkotten, December 2, 1875." It was a momentous day for Sister Henrica. Earlier that morning, Mother Clara received Sister Henrica's profession of final vows as a member of the congregation. That afternoon, she said goodbye to homeland, family, sisters, and her dear friend Mother Clara as she left for the port of Bremerhaven and the awaiting *Deutschland*.

On the second day at sea, the *Deutschland* was caught in a terrible storm. The steamer ran aground on a sandbar off the coast of Harwich, England. The *Deutschland* remained lodged with a broken propeller. Calls for help went unheeded due to the howling winds and low visibility. Huge waves crashed across the deck of the doomed ship. Among the people who drowned in the accident were the five Franciscan sisters. It was reported they had given up their space in limited lifeboats. The bodies of four sisters were found, but the body of Sr. Henrica Fassbender was never recovered. Franciscan priests were sent to accompany the remains of the sisters as they were transported by train to Stratford, England. The sisters were buried from St. Francis Church (pictured) in Stratford with a requiem mass celebrated by Card. Henry Manning of London. His Eminence offered the eulogy for the sisters, who had yet to be individually identified. Newspaper accounts estimated more than 40,000 people lined the streets of the village as the funeral processed to St. Patrick Cemetery in nearby Leytonstone.

Mother Clara Pfaender sent this telegram to Rev. Edward Schindel in the United States announcing the tragic news of the accident. The information was a severe blow to all the sisters in Salzkotten, Germany, and St. Louis, but the sorrow was magnified for Mother Clara Pfaender. Added to the community's heartache was the fact that they could not attend the burial of their beloved sisters in England.

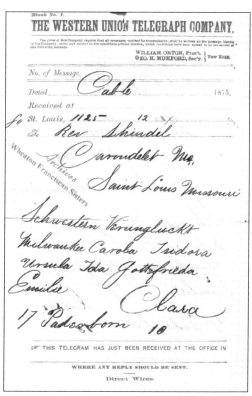

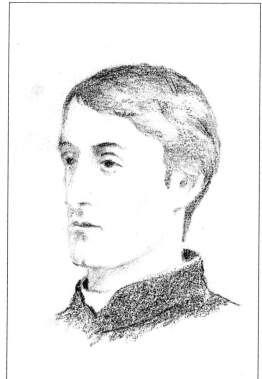

The newspapers were filled with grim details of the *Deutschland*'s loss of life. Many were moved to profound sadness, including Jesuit priest-poet Gerard Manley Hopkins. Deeply touched by the tragedy, Hopkins turned to poetry. His resulting masterpiece, *The Wreck of the Deutschland*, dedicated to the sisters, celebrates Hopkins's deep sense of God's presence in the face of disaster and memorializes the sisters. This sketch by artist Wilhelm Foeckersperger was commissioned by the Gerard Manley Hopkins Festival, Monasterevin, Ireland.

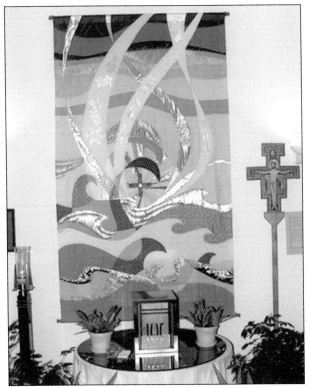

At the motherhouse in Wheaton, the Deutschland Chapel was dedicated in March 1994 to honor the five sisters drowned in the wreck of the *Deutschland*. The centerpiece of the chapel is a quilted artwork (pictured at left) commissioned by the Wheaton Franciscans. It was made by Sr. Josephine Niemann and Sisters of the Liturgical Fabric Arts of the School Sisters of Notre Dame in St. Louis. The vivid imagery found in Gerard Manley Hopkins's poem is intricately detailed in the wall hanging. In the center hangs a cross (photographed below) with five small glass spheres. Each of the arms of the cross bears a sphere containing a piece of a habit representing the four sisters whose bodies were recovered. The sphere at the center of the cross is empty and represents the unrecovered body of Sr. Henrica Fassbender.

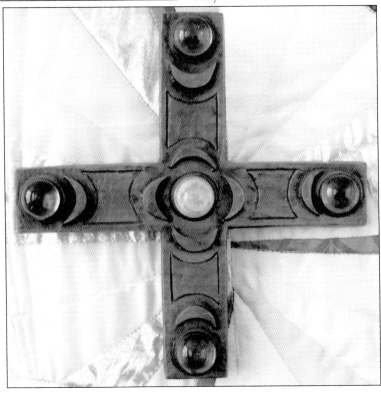

Three
ROOTED IN THE GOSPEL

This passport picture of Elizabeth Boeddeker, age 23, was taken on the day she left Salzkotten, Germany, for America (June 28, 1924). With great weariness and the dirt of train travel already on her face, it captures the sacrifice of coming to serve in the United States. Dressed in her postulancy garb, Elizabeth Boeddeker had entered the community in Salzkotten just months before leaving. She would become Sister Edelberta.

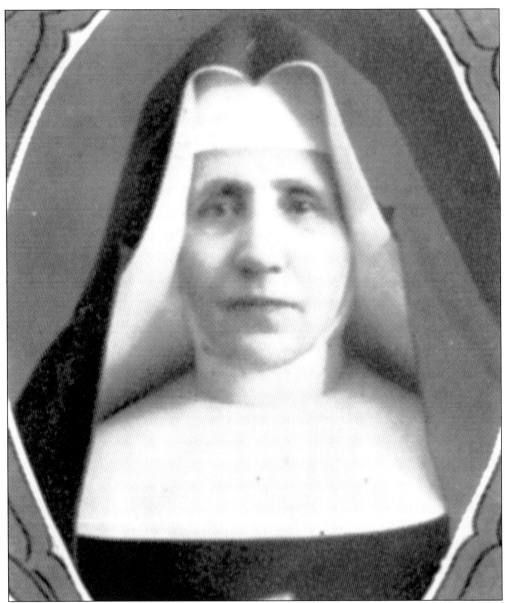

Despite the heartaches and tragedies of these years, or perhaps because of them, the American region prospered. Requests for sisters grew and, thankfully, many of them continued to respond despite personal risk. In 1876, seven sisters left Salzkotten, Germany, for the United States. Sisters were asked to teach at St. Mary's Parish in Cape Girardeau, Missouri, and additional sisters were asked to serve at Pio Nono College. Fr. Theodore Bruenner made his appeal for more sisters directly to Mother Clara Pfaender to fulfill his dream of a school for hearing-impaired individuals. Sr. Longina Sommer (pictured above from zinc cut) arrived in Wisconsin before the institute had been built. A certified teacher in Germany, Sister Longina was instructed in English and sign language by Father Bruenner and became fluent in both. When the Deaf Mute Institute opened in 1877, Sister Longina became its first teacher for the hearing impaired. Sister Longina would go on to become novice directress (spiritual teacher of the young sisters). She would be a pioneer again as one of the first sisters to go to Denver, Colorado.

The small house used for St. Francis Hospital in Cape Girardeau soon became inadequate. The sisters bought the adjacent property in 1882 and had this larger house built. The old facility was used for the kitchen and storage. St. Francis Hospital was the only hospital in the area at the time, and it served a wide section of southern Missouri. In 1886, a steamboat boiler exploded on the nearby Mississippi River. Those who survived the initial explosion suffered severe burns and were brought to St. Francis Hospital for emergency care. Some patients were placed on borrowed cots, while others were laid on bedding on the floor. No one was turned away. This was yet another occasion when the sisters' compassionate and generous response to a local misfortune knitted them deeply into the life of the community. St. Francis Hospital was in the sisters' charge for 116 years. St. Francis Medical Center honors its heritage with the Franciscan sisters as it continues to serve a large population from southern Missouri and surrounding states. (Courtesy of St. Francis Medical Center.)

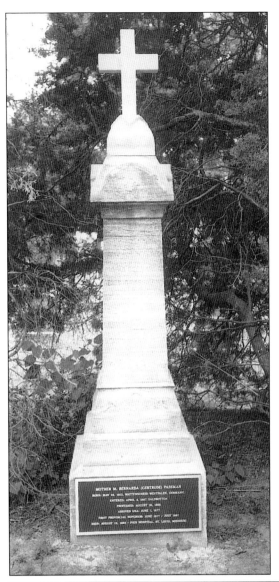

After the tragedy of the *Deutschland* in which Sr. Henrica Fassbender died, Mother Clara Pfaender put her confidence in the experienced Mother Bernarda Passmann. She had already helped to establish a large hospital in France. In 1877, at the age of 64, Mother Bernarda became the first superior of the sisters in America and led the province for 10 years. There were countless times the sisters' initiative in the United States could have failed and almost did, but the mercy of God prevailed. Mother Bernarda's practicality and wisdom gave the sisters a firm footing that ensured future growth beyond anything she could have imagined. Held in great esteem, Mother Bernarda is the only sister to have a monument headstone in her honor (pictured at left, marker detail below). She was buried at Calvary Cemetery in St. Louis in 1894.

MOTHER M. BERNARDA (GERTRUDE) PASSMAN
BORN: MAY 28, 1813, WATTENSCHEID WESTFALEN, GERMANY.
ENTERED: APRIL 4, 1867 SALZKOTTEN
PROFESSED: AUGUST 10, 1868
ARRIVED USA: JUNE 7, 1877
FIRST PROVINCIAL SUPERIOR: JUNE 1877 - JULY 1887
DIED: AUGUST 13, 1894 - PIUS HOSPITAL, ST. LOUIS, MISSOURI

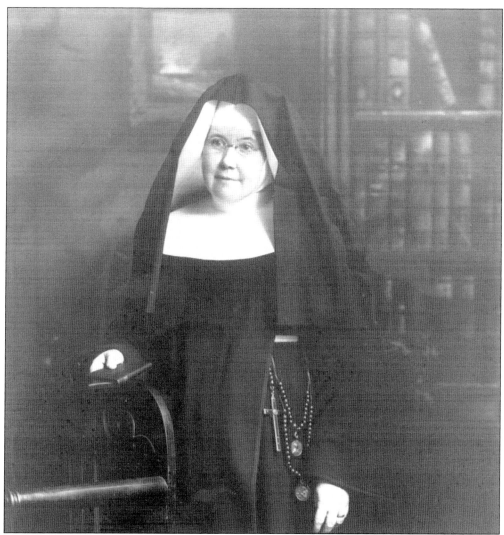

Sr. Theodora Brockmann is photographed here as a young sister. She was one of five sisters to come to America in September 1875. Days after her arrival at St. Boniface Hospital, Sister Theodora was asked to go with Sr. Scholastica Kreckler to start the parish school at St. Mary's Parish in Cape Girardeau, Missouri. Prior to her leaving on a boat down the Mississippi River, it was suggested Sister Theodora go to St. Louis to take instruction in playing the organ, as it was determined that Sister Theodora would be the organist and director of the school choir in addition to her teaching responsibilities. It seemed there was full confidence in her capacity to learn. Sister Theodora had never played the organ! She was elected as assistant provincial directress and secretary in 1884 and continued in those positions until 1906. She intermittently served as novice mistress during those years as well. Many are grateful for her well-documented history of the foundational years of St. Clara's Province in the United States.

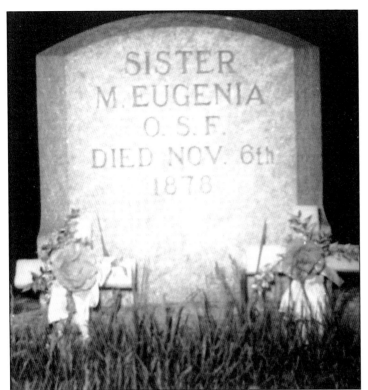

Remembered with a simpler marker is Sr. Eugenia Kruse, the first sister to die in America. She died on a begging tour in Cross Plains, Wisconsin, in 1878. Sixty years later, Franciscan sisters visited the grave at St. Francis Xavier's parish cemetery, intending to bring her remains back to Wheaton. They changed their minds when they discovered the local parishioners were devoted to her and claimed her as "Our Sister."

In 1877, lightning struck St. Boniface Hospital in south St. Louis. The sisters' first hospital in America burned to the ground. During the fire the sisters focused only on saving lives, and, gratefully, that was accomplished. All material belongings were destroyed except the Blessed Sacrament and a statue of Our Lady (pictured). The statue remains in the sisters' dining room in Wheaton like a phoenix and beacon of hope.

The sisters, already intimate with poverty, were now homeless. Their love and belief in God was all they had left. Somehow it was enough. Sr. Theodora Brockmann remembers, "In all this, we could not but see the providence of God ordering all things for the best." While some sisters went with the rescued patients for continued care at Gillick's Hall, others moved into a rented "furnished" house in St. Louis with a bed and chair. The sisters slept on bare floors. Mother Bernarda Passmann's godchild was the local parish priest. He visited the sisters and, moved by their poverty, had a wagonload of household goods and furniture delivered the next day. After several moves, the sisters finally settled on a plot of land at Fourteenth and O'Fallon Streets in St. Louis. Sewer and water pipes were already in the ground, and it was across the street from a parish church. There were several buildings on the lot, and after some renovations, space was allocated for a home for young women and a convent for the sisters (pictured, painting in zinc cut).

The Franciscan sisters were overflowing with gratitude to God when they finally had a place to call home. They began to feel their roots growing in American soil. A trusted attorney, Henry Spaunhorst, offered his services to the sisters, asking for prayer as his only compensation. He set about securing the community's civic rights and completed articles of incorporation. This first seal of 1878 states simply, "Franciscan Sisters, St. Louis, MO." By 1883, the distance between the United States and Germany seemed to grow even wider. Finding it difficult to grasp the rapid expansion in the United States, the congregational leaders in Germany made the decision that the United States would have its own governance while remaining under the general leadership in Germany. In 1884, Mother Bernarda Passmann was selected by her sisters in the United States as the first elected provincial superior of the newly established province, named St. Clara's Province.

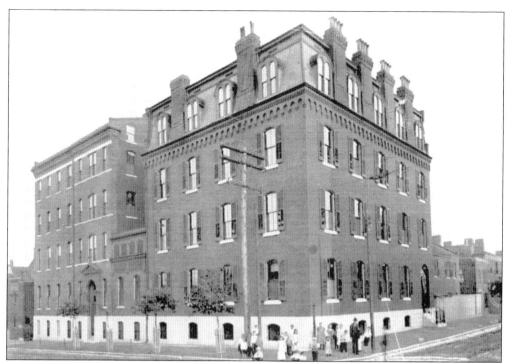

The sisters focused on their common life of prayer and especially the adoration of the Blessed Sacrament. They had always begged for alms, and the tradition was continued for funds for their ongoing work. Eventually the sisters were able to build Pius Hospital and Motherhouse (zinc cut) on the O'Fallon Street property. In October 1879, friends and benefactors from throughout St. Louis gathered as the chapel was consecrated.

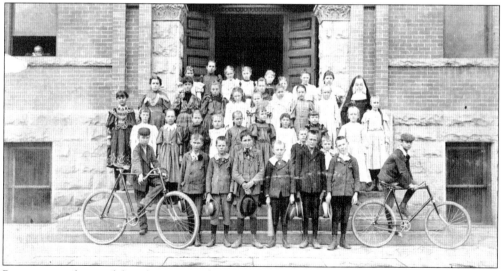

Recognizing the need for education and nursing, sisters taught in seven parishes in three states (Missouri, Illinois, and Colorado) between 1881 and 1890. As the hospital work increased, many sisters left parish schools to assist in staffing the hospitals. This photograph taken in 1897 shows Sr. Clara Jung (one of the first of many sister pioneers to the West) with children who attended St. Elizabeth's Parish School in Denver, Colorado.

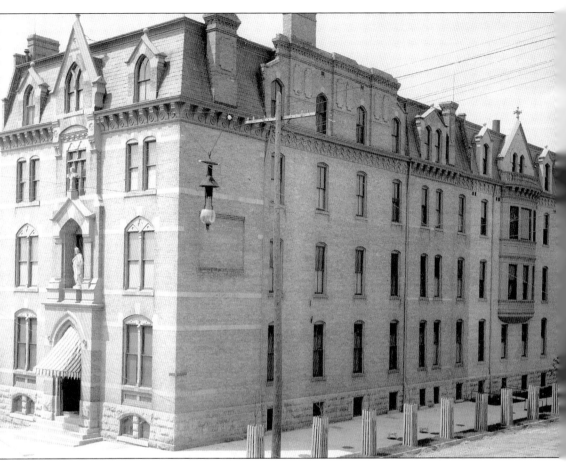

In the 1870s, Milwaukee was growing. Local priests asked the sisters to establish a hospital to serve the German immigrants settling in the area. Mother Bernarda Passmann met with Bishop Michael Heiss of Milwaukee in 1879. Bishop Heiss suggested the sisters begin their mission by nursing patients in their homes. The sisters rented a small space with a stove for one pot and meager furniture. Newspaper was used as a tablecloth. The people of St. Francis Parish in Milwaukee were grateful for the presence and services of the sisters. They would express their gratitude by leaving donations of vegetables or a sack of flour placed at the sisters' door. As the new mission grew, a larger house was rented at Fourth and Reservoir Streets, and by 1882, the plot of land was purchased by the sisters. The archbishop granted his permission for a hospital to be built. St. Joseph's Hospital (pictured) was dedicated in 1883.

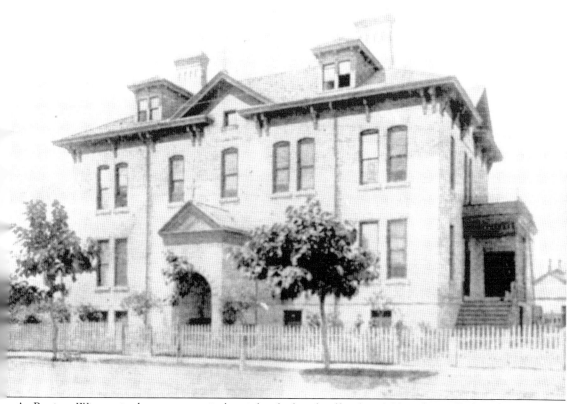

As Racine, Wisconsin, became more industrialized, church officials in Milwaukee called on the Franciscan sisters to start a hospital for the small town on Lake Michigan. St. Mary's Hospital had its origins in 1882 in a renovated hotel. In May 1883, a destructive tornado swept through the northern section of Racine. Many lost their lives and homes. The injured received compassionate and skilled care from the sisters. In addition to caring for the physical needs of patients, the sisters carried water from an outside pump and hauled buckets of coal. The townspeople came to revere the sisters and made significant donations to them. A lot was purchased adjacent to the hospital in 1886 and was used as a vegetable garden. The space in the old house had become inadequate to meet the needs of the growing town. Consent to build a new hospital was received, and in 1889, this building was dedicated as the new St. Mary's Hospital.

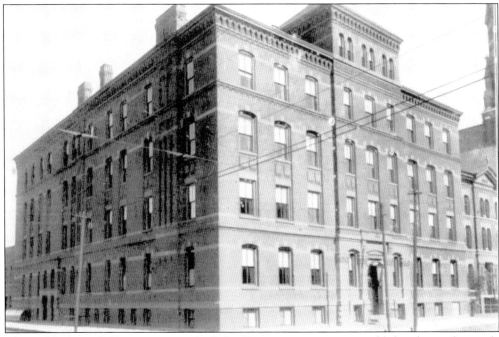

The archbishop of Chicago approached the Franciscan sisters to establish a home for single women seeking job opportunities in the growing city. In 1882, they purchased the former rectory of St. Joseph's parish in Chicago and named it House of Providence. Here residents were provided the simple comforts of home. The need for more space soon warranted renovations and additions to the property. This picture (zinc cut) was taken after construction was completed in 1892.

In 1885, Mayor A. Hamilton Levings of Appleton, Wisconsin, invited Franciscan sisters to found a hospital. The sisters were unable to act until 1899, when the city agreed to give land for the hospital. A meeting on November 19, St. Elizabeth's feast day, solidified the plans, thus the hospital's name. This photograph shows the first hospital site with a child in the yard. (Courtesy of St. Elizabeth Hospital.)

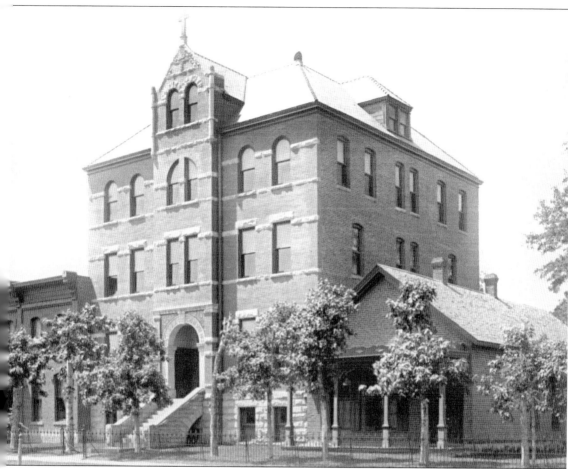

By 1888, requests were coming from as far as Denver, Colorado, for the sisters' assistance. Franciscan friars wanted sisters to teach in their newly established St. Elizabeth's Parish. At first, Mother Cecilia Hawig, new provincial directress, refused. She rethought the request when two letters came from Theresia Mellein, whose two daughters had joined the community. After a visit to Denver, the decision was made to send three sisters to teach at St. Elizabeth's Parish School. The sisters lived in the poorest of conditions, and the high altitude caused the sisters to become ill. In 1890, the people and pastor of St. Elizabeth's found a suitable lot with two brick buildings at Tenth and Champa Streets for the sisters. The larger home was repaired for the sisters' dwelling. On Christmas night that same year, four children who had recently lost their mother were brought to the sisters. The need for an orphanage became evident, and in 1893, an addition was built. The new building (pictured) connected the smaller buildings on the property and accommodated significantly more children.

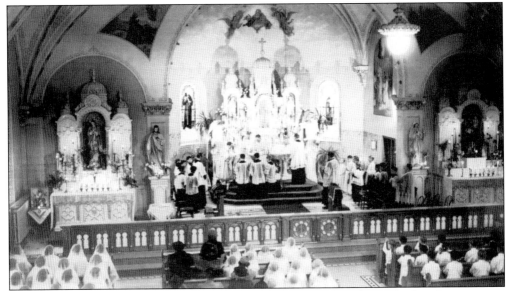

St. Clara's Orphanage continued its rapid growth, necessitating a larger facility. Sixteen acres of land were found at Twenty-ninth Avenue and Osceola Street in Denver. The plans for the new building included a large chapel (image above of Confirmation Day 1937), classrooms for children (kindergarten through eighth grade), dormitories for the children, and a convent for the sisters. In April 1909, 140 children and 17 sisters moved into the new St. Clara's Orphanage. At the height of its service, St. Clara's was home to 365 children. More than 350 Franciscan sisters served thousands of children until 1968. The photograph below shows the lovely entrance to the orphanage with cornfields on either side. The sisters provided the children with a loving home, many activities, and special outings that included annual picnics and trips to the circus.

Through the abundant grace of God, the diligent work of the sisters, and the generosity of benefactors, the motherhouse was debt free by 1892. The sisters had earned a reputation for providing exceptional care in their many ministries. After 20 years in the United States, they had successfully established hospitals, homes for young women, and an orphanage. They were teaching in parish schools. The sisters modeled goodness and love through their faith in God and good works. Young women were eager to join and membership grew. The sisters concluded that Pius Hospital and the current motherhouse were inadequate. They found a property on Grand Avenue and Chippewa Street in St. Louis with fruit trees and large shade trees. On St. Anthony's feast day, June 13, 1894, the sisters moved to their new home and hospital. (Photographs by Samborsky Photo.)

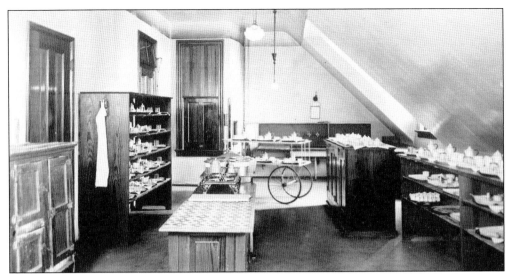

In just four years, it was clear that more space was needed for both the hospital and the motherhouse. The sisters received approval from Archbishop John Kain in St. Louis for construction of the new motherhouse and hospital on the property at Grand Avenue and Chippewa Street, but the concern was the lack of funding. A rapid answer to the funding question came when a priest offered the sisters a $30,000 loan. Building began in the fall of 1898, and by 1900, the new St. Anthony's was dedicated. The old hospital would always be affectionately referred to as "Little St. Anthony's." These photographs were taken in 1906 inside the new St. Anthony's Hospital. The picture above shows the fourth-floor pantry, and the image below captures the sunroom. (Photographs by Ruth Photo.)

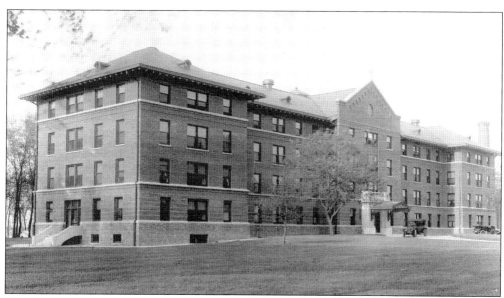

The civic community of Waterloo, Iowa, was anxious for a hospital, and Fr. Henry Forkenbrock, pastor of St. Mary's Church in Waterloo, made a request to the Franciscan sisters on behalf of the people. The citizens agreed to raise money for the hospital and to donate land for its use in 1907. The final agreement, however, was not reached until 1911, when at long last the cornerstone was laid in an outdoor celebration. Seraphic Heights was chosen by the sisters as the name for the new hospital (pictured above). On the day of the hospital's dedication, Archbishop James Keane of Dubuque asked the sisters to change the name to St. Francis Hospital. Although the sisters already had a hospital in Cape Girardeau, Missouri, named St. Francis, they simply added another. The hospital's chapel is pictured in the photograph below.

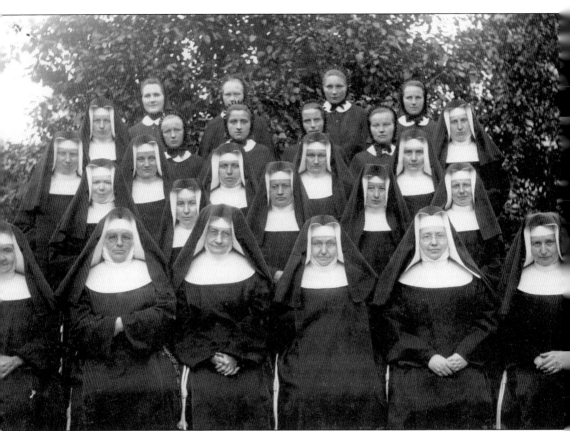

Between 1907 and 1923, no new sisters made the trip from Salzkotten, Germany, to America. Instead, the American province attracted new members through its personal contacts at the hospitals, the orphanages, and the residences for women. Sr. Dionysia Diebold, Mother Vita Klitsch (provincial directress), and Mother Celestine Wehner attended the general chapter in Germany in May 1924. They remained in Germany for the summer and visited relatives. They traveled to various missions in the Netherlands and Germany. To their surprise, several postulants, novices, and vowed sisters in various missions offered to come to the United States. Twenty sisters made the voyage to the United States that year. Sr. Davina Pietz (second row, third from left) told the story of being caught unaware when the call for volunteers was made. As she adjusted her veil, her gesture was taken as willingness to volunteer! The sisters and postulants are photographed here in Salzkotten before their trip to America. Sister Edelberta is in the fourth row, second from left.

Four
FAITHFUL TO VALUES

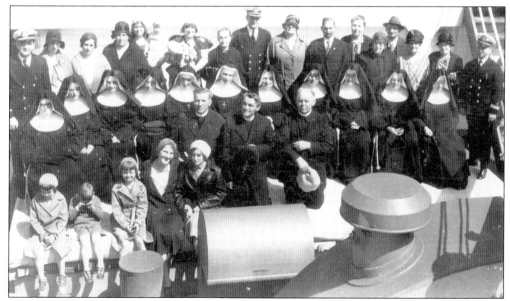

The dawn of the 20th century brought growth and expansion as well as enhanced international relationships. This 1931 photograph, taken aboard the USS *Republic*, shows Franciscan sisters with other passengers and crew. The ship was bound for Germany where the Franciscan sisters would attend a general chapter. This journey was undertaken by numerous sisters, an experience that connected one century to another.

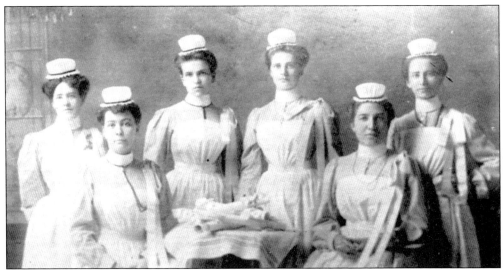

By the early 1900s, the Franciscan sisters and their ministries were flourishing, thanks to God's blessings and exceptional counsel from clergy and lay businesspeople. Increased utilization of the hospitals and the expansion of health care services meant new buildings and additions at each site. Meanwhile, technical advances were rapidly changing the field of medicine. This contributed to an increased need for lay and religious nurses. St. Anthony's Hospital (St. Louis) and St. Mary's Hospital (Racine, Wisconsin) initiated nursing schools. St. Joseph's Hospital in Milwaukee merged with the only medical college in Wisconsin (the Presbyterian College of Physicians and Surgeons) in 1898, and a school for nurses started the following year. The St. Joseph's Hospital School of Nursing transitioned from a one-year nursing program to a three-year diploma program by 1915. The graduating classes of 1901 (above) and 1902 (below) are pictured. (Courtesy of Marquette University Archives.)

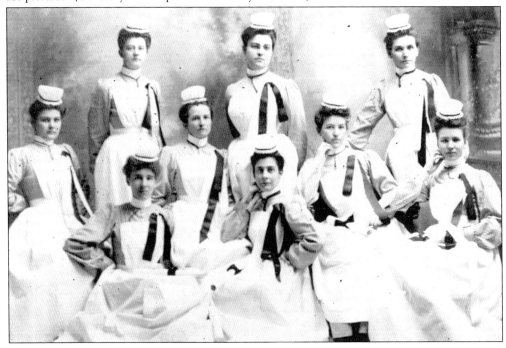

The St. Joseph's Hospital School of Nursing was built on the grounds of the hospital in 1902. It is pictured above in 1922. It provided a comfortable residence for nursing students who attended classes at the hospital during the day and often worked evening or night shifts as aides. The nursing program was needed to train nurses to work at St. Joseph's Hospital and other hospitals throughout the Milwaukee area. By 1936, the school of nursing became a collegiate program through Marquette University. The photograph below shows sisters enrolled in the nursing program at the College of Nursing in a laboratory classroom around 1945. Many Franciscan sisters went to school at Marquette for their initial nursing education or to complete their degrees.

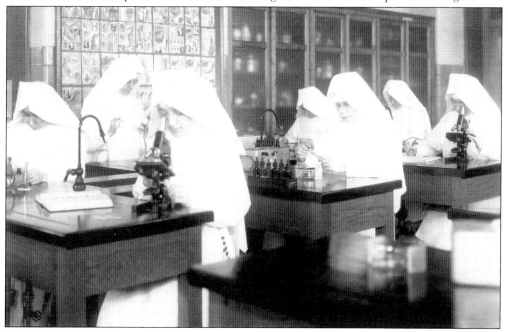

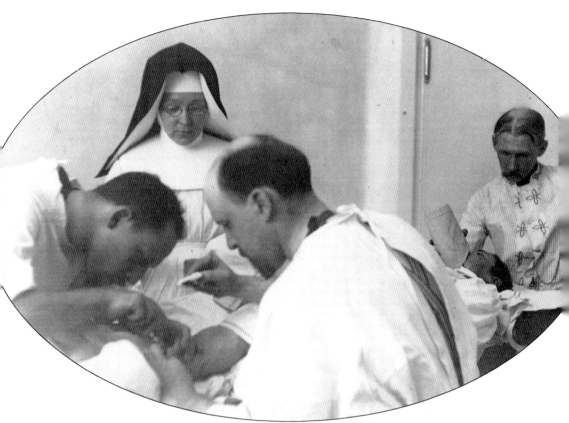

Sr. Lidwina Weber is photographed here with Dr. Victor Marshal (left) as he performs surgery on a patient's leg with two other assistants around 1910. Dr. Marshal wrote a book titled *Doctor, Do Tell!* (1945). He devotes several pages to Sister Lidwina. Dr. Marshal and Sister Lidwina worked in the operating room together at St. Elizabeth Hospital in Appleton, Wisconsin, for more than 18 years. He describes her as energetic yet always displaying a calm serenity. Sister Lidwina was serving at another mission when her friends at St. Elizabeth heard that she had become ill with malaria. She returned to St. Elizabeth for further recuperation and later was able to resume light duty, although she never did return to the operating room. Sister Lidwina was born in Chicago in 1874. Like many people born of German heritage in this country at that time, her personal effects are written in German. Thankfully, Dr. Marshal's brief written sketch of Sister Lidwina remains.

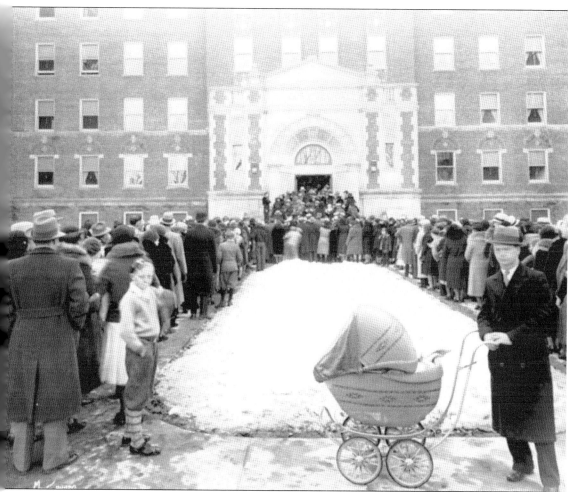

Sr. Regina Kaslin served at St. Mary's Hospital in Racine, Wisconsin, while a new hospital was being constructed during the Great Depression. She wrote a daily journal during that time. Then as now, the sisters faithfully prayed for their missions, for the workers, and for the safety of all involved during times of construction. Sister Regina learned that 485,000 face bricks had been used to construct the new hospital, and she promised a Hail Mary for every brick once everyone had safely transitioned to the new hospital. Sister Regina wrote, "I prayed Hail Mary's every day for nine years in thanksgiving." An open house was scheduled on March 26, 1933, from 1:00 p.m. to 5:00 p.m., for members of the community to see their new hospital (pictured). The crowd was so large people had to be turned away without having a chance to tour the new facility. The sisters held subsequent open houses each Sunday afternoon until all who were interested had the opportunity to visit the hospital. (Photograph by May Photography.)

In 1935, Sr. Berenice Beck (pictured) was the first woman religious in America to earn a doctorate. She received the first doctorate in philosophy of nursing education awarded by Catholic University (Washington, D.C.). She authored two books and many articles for professional journals. Sister Berenice directed St. Joseph's Hospital School of Nursing and was instrumental in establishing Marquette University College of Nursing, serving as its first dean (1936 to 1942). (Courtesy of Marquette University Archives.)

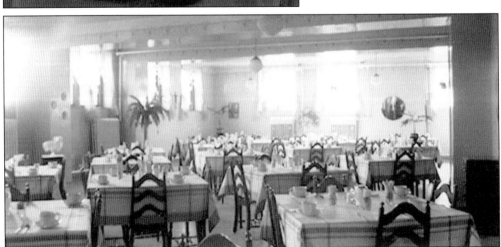

In 1909, when St. Clara's Orphanage was moved to another location, the sisters honored a request from Bishop Nicholas Matz to renovate the old building as a residence for young women seeking job opportunities in the growing city of Denver, Colorado. St. Rose's Residence was dedicated in November 1909. It served women until 1967. Pictured is the homey dining room during the 1920s.

In 1919, an addition was added to St. Rose's that doubled the occupancy. With the new addition, St. Rose's could accommodate up to 180 women, either for short stays or permanent residence. The rates were always reasonable. In the 1920s, the $7–$10 fee per week covered room with three meals a day. In the 1940s, the rates increased to $11–$12 per week. Through the years of service, St. Rose's was home for more than 9,000 women. There were no requirements or restrictions for women staying at the home. In the photograph on the right, Sr. Olga Koch makes altar bread at St. Rose's to support the cost of the ministry. By 1947, the sisters supplied altar bread to 57 parishes and institutions. The photograph below shows the comfortable library in the residence.

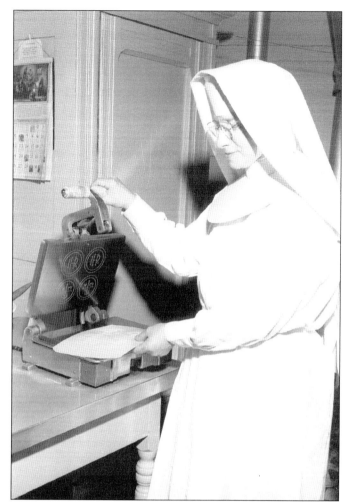

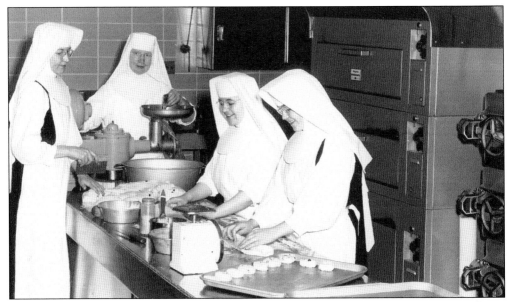

Mother Clara Pfaender wrote that the sisters are to "endeavor to integrate the contemplative and active life so that the active life is nourished, strengthened, and supported through the contemplative." The sisters' lives were built around prayer, adoration, Eucharist, and service. In the early days, they tended large gardens, conquered mountains of dirty laundry, milked cows, and gathered eggs. Before electricity and central heating, they stoked fires (first wood, then coal) and lit candles and oil lamps. Each day consisted of long hours of cooking, sewing, mending, maintenance, and housework. The sisters did all this while caring for individuals as well as owning and managing large institutions. As evidenced in these pictures taken in the late 1950s, the sisters' structured community life of work and prayer remained almost unchanged during the first 100 years.

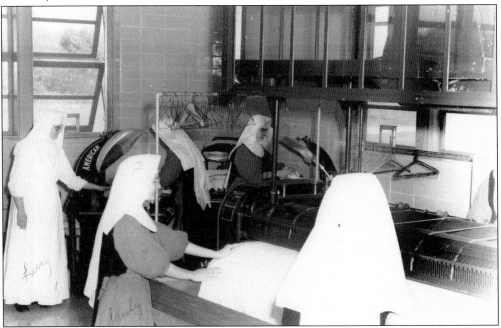

The faculty of Marquette University School of Medicine proposed that Catholic health care leaders establish standards for practice as scientific advancements changed medicine. Thus, the Catholic Hospital Association began in 1915. The organization would ensure a focused Catholic mission. Three hospitals owned by the Franciscan sisters were charter members. The era brought specialization into medicine. Sr. Regina Riegling, photographed, was the first Franciscan sister to become a registered nurse in 1913.

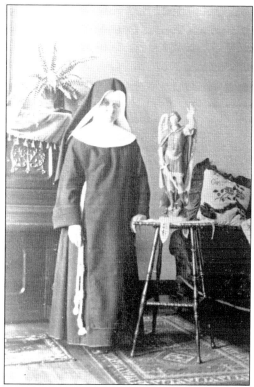

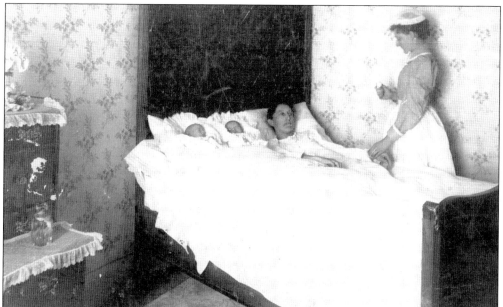

Some Franciscan sisters were trained as public health nurses. Woven into the sisters' institutions was the philosophy of considering the individual (socially, emotionally, and physically) as a whole person. The sisters' treatment of the family as a unit was a natural outgrowth of this belief and training. This photograph is of a student nurse from St. Joseph's Hospital School of Nursing attending a home birth of twins around 1910. (Courtesy of Marquette University Archives.)

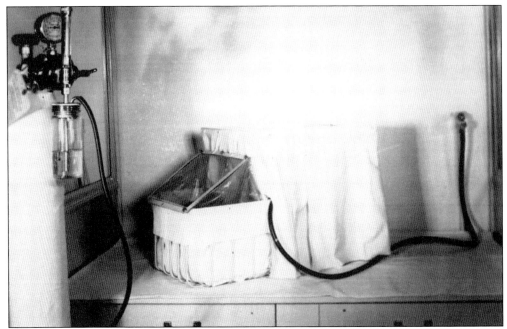

The infant mortality rate was high in the 1930s. To reverse this trend, Sr. Pulcheria Wuellner, a nurse at St. Joseph's Hospital, developed Wisconsin's first premature baby nursery. She started one of the nation's first breast milk banks. Most importantly, Sister Pulcheria, a premature baby herself, fashioned a canvas-covered, portable incubator (photographed) that regulated humidity, oxygen, and temperature. Because of its affordable design, many premature babies lived. (Courtesy of St. Joseph's Hospital.)

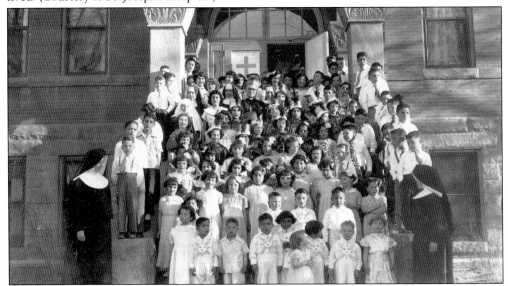

Motivated by his deceased wife's wishes, Capt. John Lambert (Pueblo, Colorado) wanted to make a significant contribution to disadvantaged children. Upon meeting the Franciscan sisters, he pledged, "I will care for the Sisters and the children as if they were my family." Sacred Heart Orphanage was built in Pueblo in 1903 and served children until 1981. This 1952 photograph shows Bishop Joseph Willging (top, center) with children and sisters.

Even with Captain Lambert's generous contributions, funds were scarce in Pueblo. The sisters went door-to-door asking for alms on a daily basis for many years. Average occupancy was 150–160 children a year, well above the planned capacity. The picture above shows the girls' dormitory in the 1940s. By 1944, all children went through the Pueblo Catholic Charities for admission. In 1961, there was an influx of children from Cuba to the orphanage. The sisters kept a two-acre garden of vegetables and a barn with 10 cows. This was a common practice throughout the sisters' institutions, as it reduced costs and provided the freshest ingredients for those whom they served. In the picture below, sisters supervise the boys during mealtime in the early 1950s. (Photographs by Glen U. Nichols.)

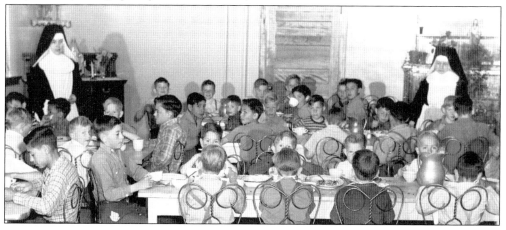

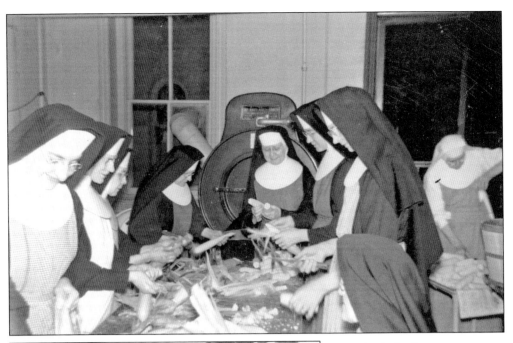

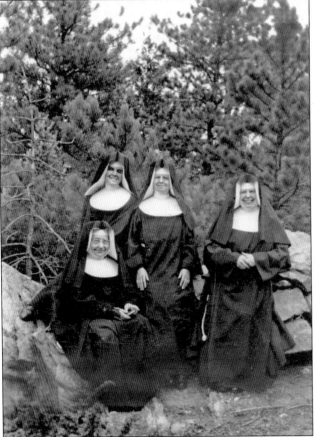

St. Clara's Orphanage was the recipient of year-round donations from local farmers and neighbors. When a truckload of seasonal fruits and vegetables was dropped off by the kitchen, word would quickly spread through the house. Every available hand was needed to put up the goods before they spoiled. In the picture above, sisters circle the table to shuck corn. The sisters who served in Colorado were awestruck by the beauty of the West. Sisters visiting the United States from other provinces around the world were anxious to visit and explore the mountains. In the photograph at left, taken in 1948, (from left to right) Mother Chrysostoma Emde (general directress from Germany), Sr. Concepta Winkelmann, Mother Maura Rossmeissel (provincial directress), and Sister Regintrudis from Germany enjoy a moment of rest while taking in the glory of the scenery.

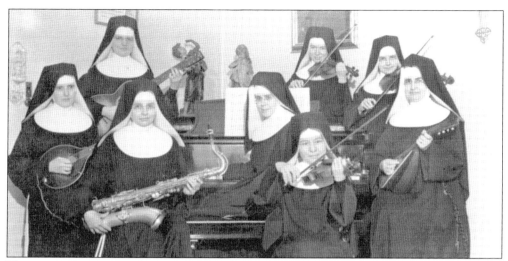

The sisters always enjoyed music of all kinds. Entertainment on a Saturday evening could vary from a square dance to a formal performance. Special presentations were held to honor the provincial directress and the novice directress on birthdays or name days. Musical entertainment was much appreciated. In the photograph above, a musical group assembles at St. Anthony's Motherhouse in the early 1940s. Members include, from left to right, (first row) Sr. Jeannette Van Domelen, Sr. Adorine Fischels, Sr. Beatrice Evans, Sr. Devota Darnett, and Sr. Christella Hilke; (second row) Sr. Damien Kieffer, Sr. Ruth Gauthier, Sr. Humilitas Broekelmann. The photograph below depicts a spontaneous break during a 1970s province gathering where music and dancing were enjoyed. Sr. Angelbert Haubner and Sr. Rosalene Van Elzen dance to the accompaniment of Sr. Vivian Breidenbach on drums and Sr. Norene Staeck on the accordion.

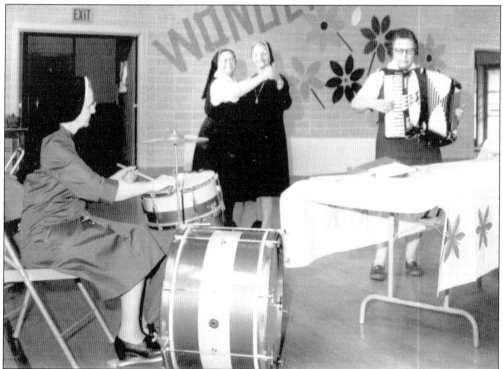

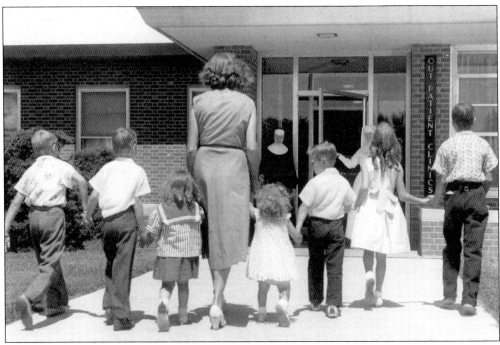

St. Joseph's Hospital moved to a new facility in 1930, and the old building was sold to a private buyer. Financial problems brought it back under the sisters' ownership by 1937. Estimates for modernizing the building were high. The sisters spoke to the archbishop about selling the property. His response is recorded to be, "Who then will care for my poor?" The sisters kept the property, made extensive renovations, and renamed it St. Michael Hospital. The new hospital focused on expanding the outpatient clinics initiated by St. Joseph's Hospital. St. Michael became a member of the Council of Social Agencies. By 1948, an alcohol treatment program began. A maternity clinic, a children's clinic, a family clinic (family entering clinic pictured above), and a dental clinic (pictured below) were some of the 22 clinical services offered. (Below, photograph by Kuhli, courtesy of Wright's, Inc.)

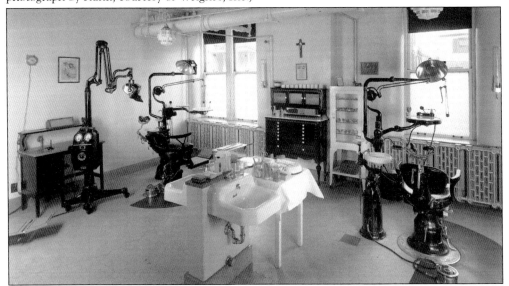

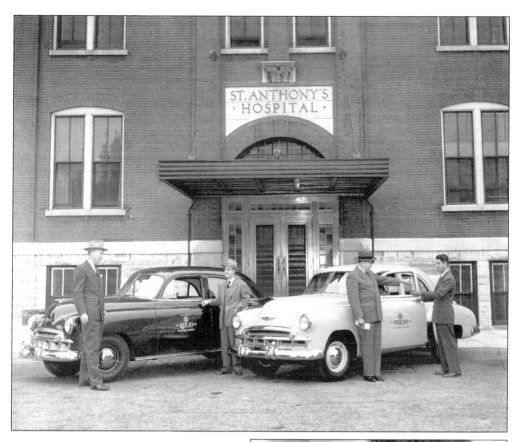

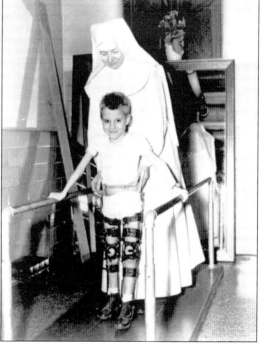

The polio epidemics of the 1940s and 1950s left children and adults disabled across the country. St. Anthony's Hospital in St. Louis became well known for its innovative techniques in caring for those with polio. By 1947, it was designated the Midwest Center for Polio Treatment by the National Foundation for Infantile Paralysis. The entire civic community was involved in battling the disease, as many volunteered to help in the hospital and others generously donated funds. In the photograph above, cars are donated to St. Anthony's Hospital for transporting patients to outpatient therapies. At the height of the epidemic, the outpatient physical therapy department treated 100 patients a day. Sr. Joanette Kleffner (pictured at right), the director of the rehabilitation department, assists a young boy to walk. (Above, photograph by George Dorrill, courtesy of Allied Photocolor; below, courtesy of St. Anthony's Medical Center.)

The sisters developed and taught polio treatment techniques to health care providers throughout the Midwest through the annual Institutes of Polio at St. Anthony's Hospital. The "Polio Center" became a model for the country in the treatment of the dreaded disease. Sr. Pulcheria Wuellner was selected to supervise the polio unit. In the photograph on the left, Sister Pulcheria tends to a young patient in an iron lung machine. In the picture below, Sister Pulcheria invites two representatives to demonstrate the use of hot-pack machines during a polio institute in 1950. Because of her extraordinary contributions, Sister Pulcheria is featured in a museum exhibit sponsored by the Leadership Conference of Women Religious. The exhibit, titled Women and Spirit: Catholic Sisters in America, is scheduled to open in spring 2009. (Left, courtesy of St. Anthony's Medical Center; below, photograph by George Dorrill, courtesy of Allied Photocolor.)

Five

MEETING THE NEEDS OF THE TIMES

This photograph of the operating room at St. Joseph's Hospital in Milwaukee shows Srs. Thomasine Mullen and Philip Smith, along with their colleagues, preparing for surgery around 1946. The sisters were an integral part of the entire hospital, from kitchen to laundry and nursing to pharmacy. During this time of expansion, sisters were the supervisors of departments, and they began to serve with an increasing number of laypeople.

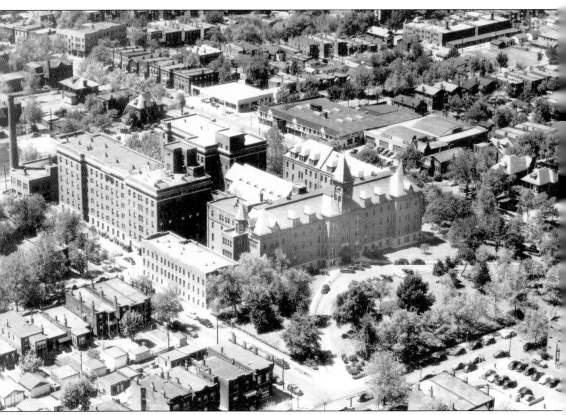

By 1946, St. Anthony's Hospital, Motherhouse, and Novitiate in St. Louis filled an entire city block (above). The bustling residential and commercial area surrounding the flagship of the Franciscan sisters left them with limited options to meet the community's growing demands. The provincial council considered two main objectives in planning for the future. A centrally located motherhouse would be practical for the province since the sisters' missions extended from southern Missouri to northern Wisconsin and westward to Iowa and Colorado. Moreover, a recent papal directive encouraged contemplative settings for the formation of women religious. As a result, the sisters wrote to the archbishop of St. Louis asking permission to move the motherhouse and novitiate outside the archdiocese if necessary. They would celebrate their 75th anniversary in St. Louis in 1947. The sisters were part of the heart of St. Louis, and St. Louis would always be in their hearts. (Photograph by G. Waters.)

In 1947, the sisters received permission from the chancellor of the Archdiocese of Chicago to purchase land 26 miles west of Chicago in Wheaton. The sisters felt the two large homes on the 90-acre property would be ideal for the motherhouse and novitiate. The road through the property was lined with tall elms. The land was beautifully landscaped with ample woods, a creek, an oak grove, and orchards filled with fruit trees. On the morning of July 1, 1947, several professed sisters and 14 novices set out for their new home in Wheaton. The larger of the two houses on the property was adapted for the novitiate. The photograph on the right shows postulants picking apples from the orchard around 1950. In the picture below, novices enjoy sledding and walking in the winter wonderland on the property in 1948.

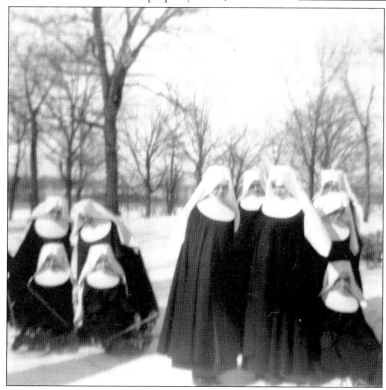

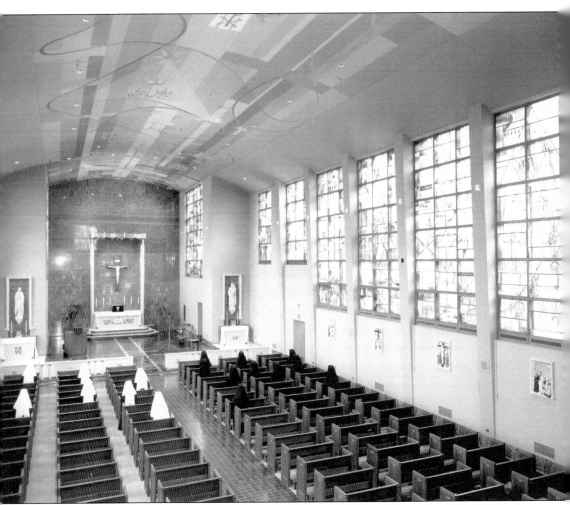

Increasing membership necessitated new construction. In the aftermath of World War II, the federal government restricted building due to the scarcity of resources such as steel and copper. However, permission was obtained in 1953 to break ground for the creation of a motherhouse and novitiate. The sisters hired Ralph Ranft to design the building. He envisioned a modern, clean structure that followed the natural slope of the land. Francis Deck from Emil Frei Associates, Inc., designed the stained-glass windows for the chapel (pictured here) depicting the "Magnificat" (the canticle of Mary from the Gospel of Luke). The windows were made from cathedral glass imported from Munich, Germany. The beautiful windows cast bright colors across the chapel from early morning until late afternoon. In 1955, Our Lady of the Angels Motherhouse and Novitiate was dedicated just as membership for the Franciscan sisters crested to the all-time high of 496 members. There was no way of knowing the future would bring many changes and fewer members. (Photograph by Stephen Lewellyn, courtesy of Lewellyn Studios.)

In 1947, a request came for sisters to open a school at Transfiguration Parish in Wauconda, 30 miles north of Chicago. Franciscan sisters had not pursued teaching for 30 years, except for the schools in their orphanages in Colorado. Three sisters began the Transfiguration Parish School. This image from around 1950 shows students with two sisters outside the building that served as school and convent at the time.

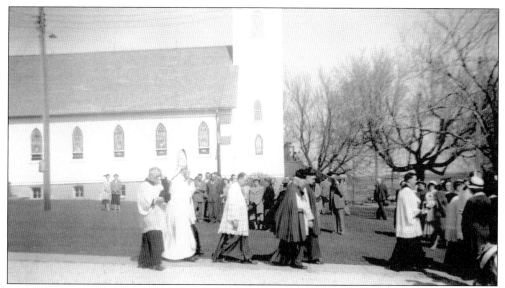

In 1950, St. Joseph's Parish in Raymond, Iowa, asked the sisters to begin a school. This picture was taken on the day the school was dedicated with the parish church in the background. Four Franciscan sisters came to work with 80 pupils that year: Srs. Marian Strevler, Elaine Georger, Pauline Langfield, and Bartholomew Spellman. The Wheaton Franciscan sisters were known to the residents from St. Francis Hospital in nearby Waterloo.

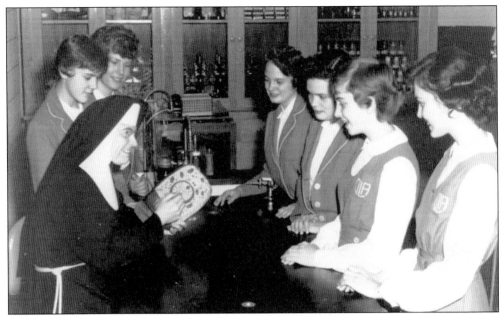

The sisters had a program for high school girls called Our Lady of the Angels Aspirancy (1957–1967). Young women, interested in religious life but too young to join the community, attended high school classes and lived on the motherhouse grounds. The program was initially under the supervision of Srs. Florence (Jude) Roling and Maryellen Archuleta. In this photograph, Sister Florence teaches a biology class around 1957.

A new diocesan high school just west of the Franciscan sisters' motherhouse in Wheaton opened in 1957. Franciscan sisters joined the Christian brothers and the Ladies of Loretto (IBVM) on the faculty of St. Francis High School. This photograph shows Sr. Marilyn Marin with her class of young women in 1957. In 1963, Sr. Pauline Langfield and Sr. Mariette Kalbac began a school for the Holy Family Parish in Pueblo, Colorado.

When Mother Fidelis Gossens was elected as the provincial directress in 1960, a main focus became spiritual renewal. She encouraged every sister to take a month-long renewal program. During the early 1960s, the sisters hosted the Franciscan Educational Conference, emphasizing Franciscan principles in ministry. In 1963, the Franciscan sisters hosted the Better World Conference. Pictured are the 167 participants from 31 different congregations who participated in the retreat. (Photograph by Orlin Kohli.)

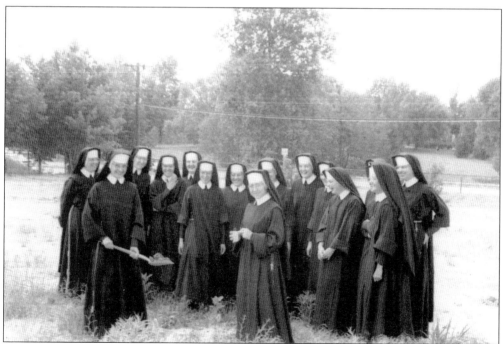

By the mid-1960s, almost 30 percent of the Franciscan sisters had college degrees, and 60 percent had postsecondary educations. Many sisters were educated at Marillac College, a Catholic sisters' college in St. Louis. In 1966, the Franciscan sisters built a residence on land adjacent to the college. In this photograph, Sr. Virginia Mary (Dolorine) Barta (left) is joined by sisters for an informal groundbreaking for construction of the building.

As the number of sisters attending Marillac College increased, the residence in St. Louis (pictured above) became congested. The house had bedrooms with bunk beds while the living room, which served as a study area, accommodated dozens of desks. Eventually it was decided to build a residency close to the college. The building in the photograph below was completed in 1966, and the sisters were eager to occupy it. The large structural overhang is the colored glass window of the resurrected Christ in the chapel. The building is still used today by the music department of the University of Missouri, with the chapel area serving as the orchestra rehearsal room because of its fine acoustics. (Below, courtesy of R. Hostkoetter Photography.)

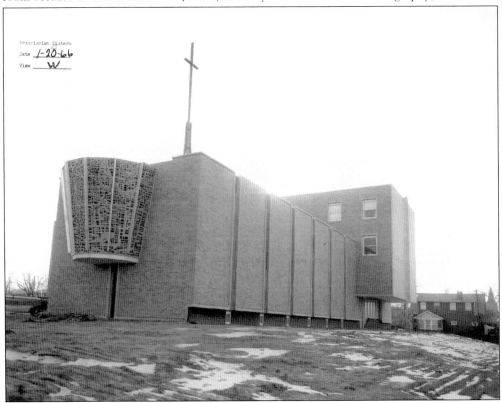

A 1959 plea from the Vatican asked religious communities to increase their missions to South America. The Franciscan sisters explored collaborating with Bishop James Ryan, a Franciscan from Chicago who was bishop of Santarem, Brazil. Mother Fidelis Gossens and Sr. Virgilia Beichler (province directress and assistant) visited Santarem, located at the juncture of the Amazon and Tapajos Rivers. The decision was made to start a medical services mission to the people in that area. Sisters volunteered for the mission, and three were selected. They began a preparation process that included an immersion course in Portuguese. The photograph above shows (from left to right) Srs. Adrienne Shannon, Gemma Backer, and Martha Friedman with Mother Fidelis before their trip in 1963. The photograph on the right shows (from left to right) Sisters Gemma, Adrienne, and Martha on their 10-day voyage to Brazil aboard the *Mormcowl*.

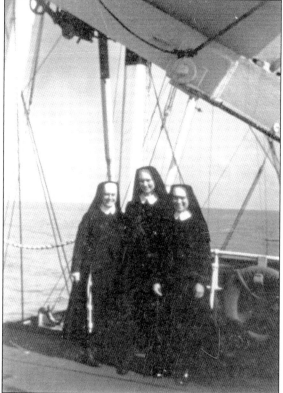

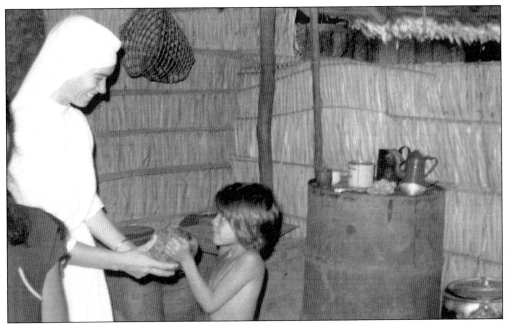

Medical supplies, household items, clothing, and medications were packed into 55-gallon barrels and sent along with the sisters to Brazil. The sisters saw extreme poverty and worked tirelessly making house calls, dispensing medications, and teaching basic hygiene. In their first year in Brazil, three sisters made 870 home visits and numerous food distributions. By 1968, the Franciscan sisters built a maternity hospital and a program was developed to train midwives. Meanwhile, back in Wheaton, sisters organized fund-raisers twice a year to collect food and medical supplies for the mission in Brazil. To this day, Brazil remains a vital part of the congregation. In the photograph above, taken in 1965, Sr. Martha Friedman receives a coconut in gratitude for her service to a family. The picture below shows Sr. Gemma Backer talking with a mother and her son in 1965.

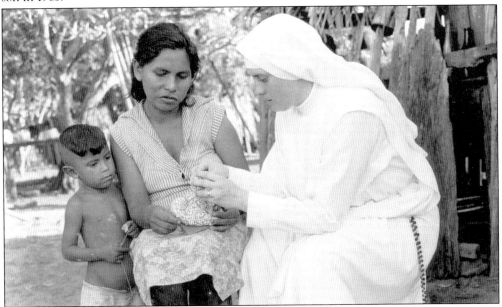

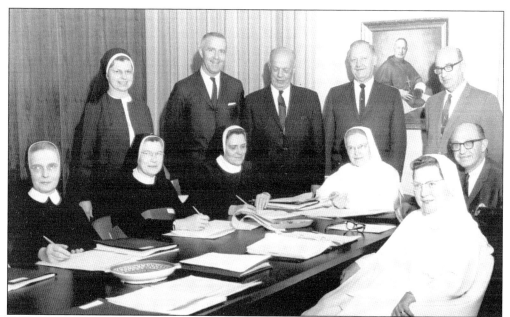

Medical advances increased demand for expertise and specialization in the hospitals while labor laws complicated issues of management and personnel. The sisters, always ready to meet the changing needs of the times, hired laypeople for managerial positions in their hospitals as early as 1948. Lay advisory boards were formed to promote solid relationships between the hospitals and the surrounding communities. The photograph above, taken in 1967, shows the newly restructured board at St. Joseph's Hospital in Milwaukee. The photograph below shows three Wheaton Franciscans (in the first row, far left, is Sr. Illumina Gossens, and at far right are Srs. Jeanne Gengler and Lillian Van Domelen) as part of a business class in 1968. Women religious filled positions of high rank in schools, colleges, and hospitals and as members of corporate boards.

A graduate of Marquette University, Sr. Jeanne Gengler (pictured in 1974) was director of St. Michael Hospital's outpatient clinics. She found working with the disenfranchised particularly satisfying. Sister Jeanne was president of St. Joseph's Hospital from 1965 until 1980. Under her leadership, the hospital became one of the largest and most sophisticated medical facilities in Wisconsin. Sister Jeanne went on to coordinate the archives of both hospitals in Milwaukee.

Sr. Rosalie Klein was the last Wheaton Franciscan sister to serve as dean of the College of Nursing at Marquette University (1970–1988). She guided the college through financial and academic obstacles until it became fully integrated under Marquette University and later wrote the history of the college in a book titled *Marquette University Nursing Education (1888–1988)*. Today she volunteers at Elmbrook Memorial Hospital, offering Franciscan presence to all.

Six

LIVING COMPASSIONATELY AND CREATIVELY

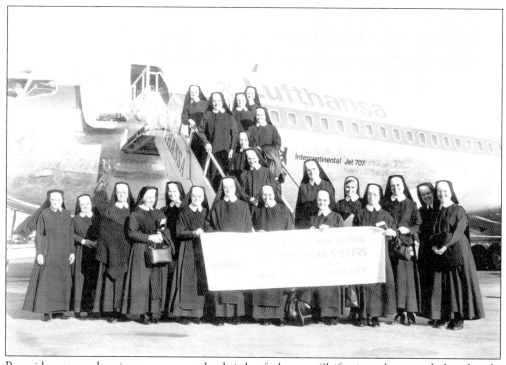

By midcentury, the sisters were on the brink of change. Shifts in culture and the church, international exchange, and increasing professionalism contributed to the ongoing evolution of the community. In this 1967 photograph, a group of American sisters take advantage of a special rate for travel to Germany. Several sisters are present to bid bon voyage to their companions. (Photograph by Mike Rotunno, courtesy of the Rotunno family).

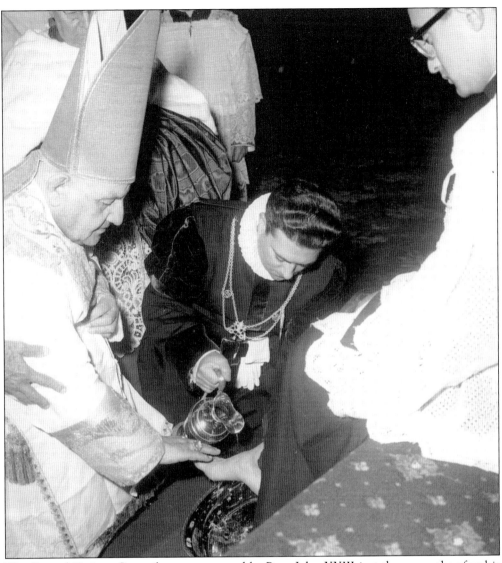

The Second Vatican Council was announced by Pope John XXIII just three months after his election in 1958. After lengthy preparation, the council opened in 1962 and lasted three years. When asked about the council's purpose, Pope John went to the window and threw it open. Fresh air was to blow through the age-old institution. He stressed the light of Christ as God's gift for all people, the need to be a pastoral presence in today's world, and the integration of contemporary theology. Women religious were directed to renew their way of life by studying their spiritual roots and by adapting both their founding purpose and their lifestyle to the conditions of the modern world and the needs of the times. Pope John is pictured here in a 1961 foot-washing service at St. Peter's Basilica. The foot-washing represents the primacy of service to others as a follower of Christ. (Courtesy of Servizio Fotografico, L'Osservatore Romano.)

The invitation for renewal was issued to the whole church, but in particular to the religious orders. The coming years would be tumultuous and transformative. Religious sisters and their life would never be the same again. As old institutional ways of living were examined and renewed, many sisters would make the choice to leave community life, while others found the new forms to be invigorating and life-fulfilling. In the 1966 province chapter, the Franciscan sisters elected Sr. Virginia Mary (Dolorine) Barta as their provincial directress. At 40 years old, she was the youngest woman to be elected. As she writes in her autobiography, "I came to the chapter with 100 proposals and was elected provincial." She is pictured at the beginning of her term (right) and later in her term (below).

The new provincial council (pictured above), Srs. Barbara DeWindt, Virginia Mary (Mother Dolorine) Barta, Marilyn Marin, Janice Teder, and Estelle Francken (absent from photograph), wasted no time in guiding the community through transition. It was, perhaps, providential that Sister Virginia Mary had recently completed her master's degree in psychology, because psychological development and group process were key elements in the transformation. Workshops in Christian leadership, scripture study, liturgy, and theology aided the sisters in understanding and integrating the changes. Formerly sisters were taught to set aside personal opinions in favor of group conformity; now they were inundated with questionnaires seeking their opinions and preferences. The hierarchical structure of religious life shifted to an "ecclesial structure" that more closely resembled the early Christian community. The picture below shows a group of sisters during a province gathering (1970) with Franciscan Fr. David Eckelkamp.

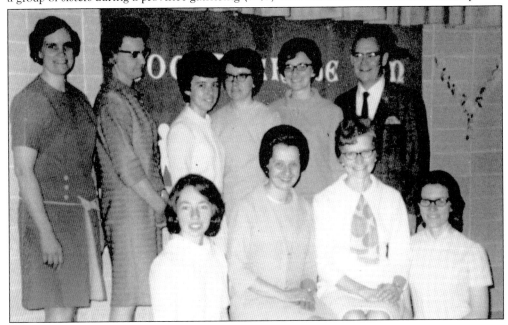

Sisters pursued individual interests for their work and ministry, developing their God-given talents and gifts. Many returned to school to pursue higher education in the fields of social work, psychology, and parish ministry. Several sisters were passionate about peace and justice issues. Sr. Julia Ernst worked with the children of Corpus Christi Parish in Chicago. She is pictured with some of the children from the parish in 1967.

Grassroots participation was encouraged as sisters researched and discussed crucial themes of their community lives in light of scripture, Vatican II documents, and Franciscan values. Position papers were composed on spirituality, religious development, the apostolate, and community structure. In 1968, these position papers, along with proposed revisions to the constitution and way of life, were distributed to the members in a book called *We Are One in the Spirit* (pictured).

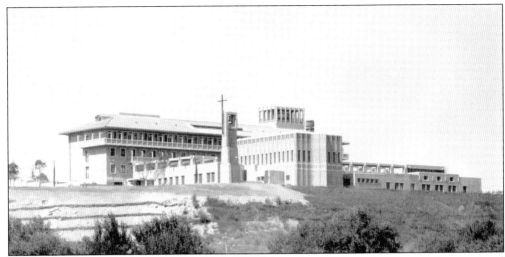

During this unprecedented change, ties were renewed and strengthened among the international family of Mother Clara Pfaender's daughters. Apparent differences faded in light of rediscovering the unifying charism. In 1968, the congregational headquarters moved from Paderborn, Germany, to a large modern building (pictured) in Rome, Italy. The headquarters remained in this building for 20 years. The deep international connection fostered among community members remains to this day.

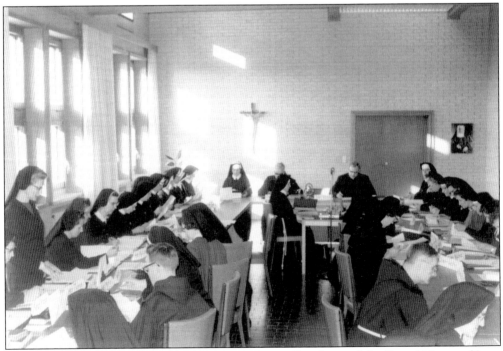

The international leadership of the Franciscan Sisters, Daughters of the Sacred Hearts of Jesus and Mary met in Rome in 1969 (pictured). The meeting focused on updating and revising the congregation's constitution. When the general chapter ended, the leadership of each province communicated the contents of the new constitution and the implications for applying the general guidelines of the constitution to the culture and needs of each particular province.

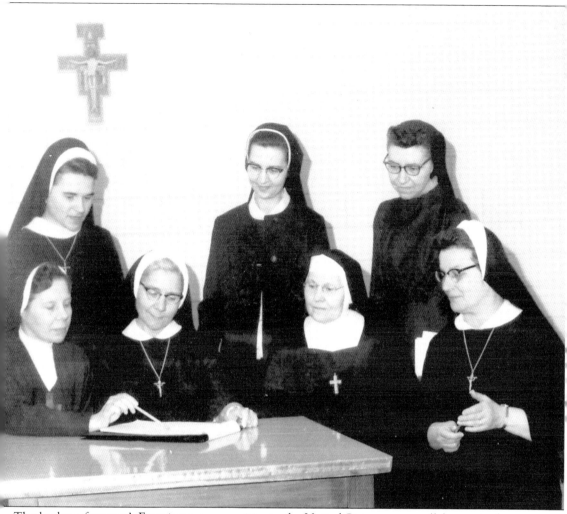

The leaders of women's Franciscan communities in the United States met to collaborate in the call for Franciscan renewal in 1965. Two years later, the Franciscan Federation was formed with a threefold purpose: to recapture the original spirit of St. Francis of Assisi, to renew a sense of community among the Franciscan women religious in the United States, and to adapt to the needs of the times. A goal of the new organization was to create a spiritual document based on the writings of St. Francis and scripture. For two years, six sisters from the national organization did extensive research on St. Francis and his writings and consulted with Franciscan experts. They worked with a wide number of Franciscan communities before writing *Go to My Brethren* (1969). The document provided a firm foundation for Franciscan women during the time of renewal. Sr. Audrey Marie (Mary David) Rothweil of the Wheaton Franciscans (as they became known) was a member of the committee. She is pictured (standing, center) with other members of the committee.

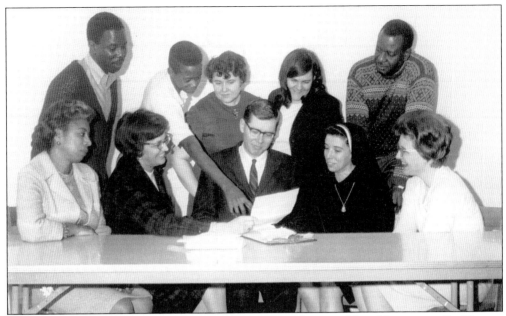

The Bridge Communication Center opened in 1968 on the site of the old novitiate. Sr. Theresa Langfield (seated, second from right) was director of the center, which offered retreats, workshops, and programs for children, young adults, and adults. Ecumenical groups were welcomed. A coffeehouse offered a place to socialize and enjoy live music. The quiet, secluded sanctuary of the motherhouse grounds was transformed into a place of public welcome.

New avenues for prayer were explored, and the gifts of meditation were rediscovered outside the confines of monasteries. Sr. Diane Przyborowski, like many of her Wheaton Franciscan contemporaries, realized a call to contemplation and meditation. Finding the benefits of this practice in her life and ministry, Sister Diane continues to teach and facilitate meditation. Sister Diane (left) and Sr. Virginia Mary Barta are pictured after offering a meditation retreat in 1977.

Mutual respect among community members was crucial as each sister found her way at this time of transition in community life. A number of sisters wished to remain in the convent lifestyle, while others wished to embrace renewed and fresh forms. The older, more institutional convent lifestyle stressed uniformity for the good of the whole. Living in small groups encouraged new patterns of relating with an emphasis on developing the authentic self and group sharing. This was quite a shift from the unquestioned hierarchy. Sisters living in convents could also pursue small group living. Household duties and meal preparations were shared. Individual prayer, community prayer, and house meetings became the responsibility of all. Shalom Community, pictured here, was one of the first small communities to be formed at the motherhouse in 1971. Pictured are, from left to right, (first row) Srs. Madeleine Metcalf, Pauline Langfield, Gabriel Robedeaux, and Barbara DeWindt; (second row) Srs. Laurine Yaggie and Norene Staeck.

Bonds of friendship developed between sisters and laypeople they encountered. As early as 1969, the Wheaton Franciscans began exploring ways in which laywomen could be associated with the community. A goal of the 1980 province chapter was to "encourage, support, and integrate into our community new members and new forms of membership." In 1983, covenant membership was developed for laymen and laywomen who wished to embrace the Wheaton Franciscans' charism and philosophy in their daily lives. Covenant membership is based on relationships with sisters and other covenant members and offers support in pursuing a richer spiritual life. Prospective members participate in an orientation and integration program before making a public commitment with the community. There are currently more than 40 people in covenant membership. The photograph above was taken during the first covenant membership ceremony in 1983. Covenant members Laurette Kelly (second from left) and Gwen Hudetz (second from right) celebrated their 25th anniversary as covenant members in October 2008. Alana Gorski (right) was a covenant member for one year prior to pursuing vowed membership.

Lack of affordable housing was a critical social problem in the late 1960s. The Wheaton Franciscans proposed a visionary plan to address the need. The sisters would use portions of their properties for affordable housing. After thorough deliberations with the city council, social agencies, and the Department of Housing and Urban Development, Marian Park opened in Wheaton in 1973. The picture above shows Sr. Sylvia Wehlisch, resident coordinator, with a young resident. Francis Heights, pictured below, was built on the grounds of St. Clara's Orphanage in Denver (1972). The Wheaton Franciscans were the sponsoring agents and managers of the properties as they involved residents in the planning, programming, and management of the housing communities. These housing developments formed the foundation of a broader housing ministry sponsored by the Wheaton Franciscans. (Above, courtesy of Wheaton Franciscan Services, Inc.; below, sketch by J. P. Britton.)

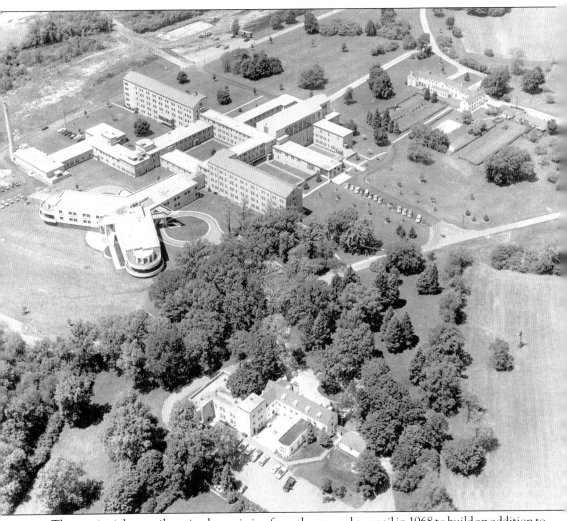

The provincial council received permission from the general council in 1968 to build an addition to the motherhouse for sick and infirmed sisters. A new and modern facility was built and dedicated as Marianjoy (the name honors Mary, the Blessed Mother, and St. Francis, who was known for his joy). The addition eventually was licensed as a skilled nursing facility and welcomed laypeople as well as sisters. In 1972, it was rededicated as an acute physical rehabilitation facility. Marianjoy Rehabilitation Hospital continues its fine work today in a new hospital on the property. This photograph is an aerial view of the Wheaton Franciscan campus in the early 1970s. In the center (left) is Marianjoy Rehabilitation Hospital (the Y-shaped building) attached to the larger motherhouse. The building in the lower section of the photograph is original to the property and served as the novitiate. The building at the top right of the picture is the other original building that served as the motherhouse. (Courtesy of James Professional Photography.)

Seven
SHARING LEADERSHIP IN MINISTRY

As community life evolved so did the sisters' ministry. Here Srs. Illumina Gossens (left) and Kenneth Huelsing break ground for an addition to St. Michael Hospital (Milwaukee) where Sister Illumina was administrator from 1964 to 1975. By the late 1960s, the sisters had seven hospitals in three states: St. Anthony's and St. Francis in Missouri; St. Joseph's, St. Michael, St. Elizabeth, and St. Mary's in Wisconsin; and St. Francis in Iowa.

During the 1960s, emphasis was placed on constructing new medical facilities to meet the evolution in health care technology and delivery. The establishment of Medicare and public aid added to the complexity of health care. Sr. Catherine (Ambrose) Albers, administrator at St. Francis Hospital in Waterloo, oversaw the planning and construction of a new facility. She is pictured with (from left to right) Archbishop James Byrne, Fr. A. Gibbs (standing), and Joseph Gaffney in 1968.

Sr. Lillian Van Domelen, pictured here, was president of St. Mary's Hospital in Racine when it was the first Franciscan hospital to institute a lay board of directors. Sister Lillian said of the development, "St. Mary's needed so much and I felt the only way to accomplish it was to get [civic] community members involved. It's a public service and the public should know what services are most needed."

Fewer sisters and the need for the expertise of lay leaders prompted administrative evolution and change in the hospitals. The provincial council appointed a task force of Srs. Rose Mary Pint, Diane Sledge, Erna Kimminau, and Thomas Kolba, who were charged with communicating the sisters' philosophy to hospital administrators and employees. Sister Thomas is pictured with Msgr. Francis Beres in the 1974 groundbreaking ceremony for St. Mary's Hospital in Racine, Wisconsin.

HCD

... respecting the sacredness of life and the dignity and worth of every person.

... creating caring communities in which the needs of those serving and being served are met.

... providing opportunities for personal and professional growth.

Human and Community Development (HCD) was embraced by the sisters as their community philosophy, firmly rooted in the Gospel and providing a clear vision for their ministries. It upheld the sacredness of life, fostered relationships, and encouraged the respectful growth and development of all people. HCD is grounded in the Franciscan principle that all creation is in relationship. Pictured here is a photograph of a pamphlet on HCD from 1987.

The task force created the Health Care Advisory Council (HCAC) in 1970 and organized a series of meetings with hospital administrators and their assistants. They discussed concerns and the implementation of HCD. Goals and objectives were developed with the hospital administrators to share the philosophy with hospital employees. In this later photograph from 1981, Sr. Rose Mary Pint meets with presidents of three hospitals. (Courtesy of Wheaton Franciscan Services, Inc.)

The provincial council created the Franciscan Sponsorship Commission in 1979 with the following members: Sr. Rose Mary Pint (director), Sr. Marilyn Marin, and Sr. Thomas Kolba. In this 1981 photograph, the Franciscan Sponsorship Commission, the provincial council, staff, and advisors meet together. The purpose of the commission was to function as staff to the province council in evolving a structure for carrying out the sisters' ministries. (Courtesy of Wheaton Franciscan Services, Inc.)

By 1976, the majority of the Wheaton Franciscans' hospitals had lay administrators and boards of directors comprised of laypeople and sisters. The provincial council appointed a second task force in 1977 led by Sr. Jeanne Gengler to research the canonical (church) and legal implications of sponsorship. Robert (Bob) Makowski (pictured above), an attorney and consultant to St. Joseph's Hospital, guided the task force work. A model set of bylaws was developed that clarified the roles of the sponsors, board, chief executive officer, and medical staff. These innovative model bylaws were adopted by each hospital. Bob Makowski was later hired by the sisters and provided wise counsel, excellent leadership, and prophetic vision through 14 years of evolution of the ministries. He recommended the development of the Clara Pfaender Fund, which began providing grants in 1989 for those served by the Wheaton Franciscan system who were most in need. He was one of the original covenant members of the Wheaton Franciscans. (Courtesy of DeJong Photography, Inc.)

The sponsorship commission was to ensure that the sisters' mission and values were woven into the fabric of every sponsored institution as more laypersons participated in leadership. In 1980, the province chapter (photographed above) mandated that the sponsorship commission create a structure for sponsorship in the health and housing ministries. A 1984 chapter directed the sisters' corporate entities to provide "preferential care for the poor." Mary Naber, vice president of mission services, proposed SET Ministry (service, empowerment, and transformation) in response in 1985. SET closes the gaps in services for people most in need in central Milwaukee. It continues to be a model of collaboration as religious communities, health care institutions, and human service organizations work together to help individuals. The photograph below shows (from left to right) Srs. Florence Roling and Beth Cosgrove with Mary Naber shortly before Naber was honored by the Franciscan Federation for her work.

On July 11, 1983, the corporate ministries of the Wheaton Franciscan sisters were incorporated as Wheaton Franciscan Services, Inc. The parent company directs and oversees the development of the system entities. At its inception, Wheaton Franciscan Services, Inc., held 21 health, shelter, and human service organizations. Sr. Rose Mary Pint was named chairperson of the board of directors, president, and chief executive officer. Bill Loebig was named executive vice president of health services, and Bob Makowski was named vice president of corporate services. Wheaton Franciscan Services, Inc., established the following priorities for its corporate mission: "preserve and strengthen Judeo-Christian values, provide a framework for lay expertise and involvement, respond to an increasingly complex environment, ensure continuity of Franciscan sponsorship, and assure system-wide viability and excellence." Wheaton Franciscan Services, Inc., has always been futuristic in its planning and bold in its initiatives. It has partnered with other lay and religious institutions to form cooperative efforts in providing health and public services. In this photograph, (from left to right) Bob Makowski, Bill Loebig, and Sr. Rose Mary Pint discuss the goals and objectives for the new corporate structure. (Courtesy of Wheaton Franciscan Services, Inc.)

The housing ministry became incorporated as Franciscan Ministries, Inc. (FMI), under Wheaton Franciscan Services, Inc., in 1983. FMI provides housing for the elderly and low-income families in Illinois, Wisconsin, Iowa, and Colorado. In the photograph above, Sr. Shirley Krull (left) is with residents Ceil Walton and Kay Kavanagh at the 25th anniversary of Marian Park. Sister Shirley, first president of FMI, entered the convent more than 50 years ago to serve the poor. She has carried out that mission by advocating for fair housing locally, serving as a missionary in Zimbabwe, and training volunteers in the Joliet diocese for missionary service. In 2008, as FMI celebrated its 25th anniversary, Sr. Beatrice Hernandez, provincial directress of the Wheaton Franciscan sisters (2008–2012), spoke about FMI's philosophy: "The founding philosophy of human and community development was the vision upon which our housing ministry was built. Today Franciscan Ministries carries on this Wheaton Franciscan housing ministry—and it is a ministry. Providing a roof over a person's head can be a job, but facilitating the creation of loving, caring, safe, and hope-filled communities is a ministry."

Sr. Rose Mary Pint (pictured) was involved in sponsorship from the time of the first task force. Her vision and enthusiasm for the work of the corporate ministries and the importance of sponsorship has been foundational and inspirational. In 1986, Bill Loebig was named the president and chief executive officer of Wheaton Franciscan Services, Inc., and Sister Rose Mary continued as chairperson of the board until her retirement from the corporate system in 1997. She created a model for the continuity of sponsorship that has been shared nationally and internationally with various religious congregations. Sister Rose Mary served the community as provincial directress from 1988 to 1992. In addition, Sister Rose Mary has served in province leadership as a provincial councilor on two previous leadership councils and began a third term of service in 2008. Through Sister Rose Mary's many roles in leadership, she maintains close relationships with all her sisters. She has coordinated the health care environment and activities of the elderly sisters living in the motherhouse for more than 10 years. (Courtesy of DeJong Photography, Inc.)

Jeanne Connolly, covenant membership coordinator for the Wheaton Franciscans, wrote her doctoral dissertation on the "Sponsorship of Catholic Health Care" in 2002. Connolly states, "Sponsorship of a Roman Catholic Church ministry [has] the canonical [church] stewardship and influence over the fundamental values and direction of the ministry. An institution operated in the name of the Catholic Church must be sponsored by an organization that is recognized and authorized by the Church." Today sponsorship of Wheaton Franciscan Services, Inc., is carried out by sisters appointed to the sponsor member board and the sponsorship member committee. The board's role is to exercise the authority of the provincial council in issues of governance and to evaluate corporate ministries in light of the mission of the church and the needs of the times. The committee consists of board members who give additional time and focus to sponsorship development and evolution. This photograph is of the sponsor member board in 2006: (from left to right) Srs. Beatrice Hernandez, Margaret Grempka, Sheila Kinsey, Clare Nyderek, Alice Drewek, Mary Beth Glueckstein (chairperson of the board), and Jane Madejczyk.

Eight
CONTINUING TO TRANSFORM

Innovation and collaboration are hallmarks of Wheaton Franciscan Services, Inc. The system has flourished as a not-for-profit organization with more than 100 health and shelter organizations in Illinois, Wisconsin, Iowa, and Colorado. The Felician sisters founded St. Francis Hospital in Milwaukee, Wisconsin (1956). The Wheaton Franciscans and the Felician sisters established joint sponsorship in 1993 when St. Francis (pictured), St. Joseph's, and St. Michael Hospitals formed Covenant Healthcare. (Courtesy of Wheaton Franciscan Healthcare.)

Bill Loebig (pictured at left) was the first layperson to be appointed as president and chief executive officer of Wheaton Franciscan Services, Inc. (1986–2000). His association with the Wheaton Franciscan sisters started during the 1970s when he was the administrator at St. Elizabeth Hospital in Appleton, Wisconsin. He was identified as an inspirational leader who challenged and trusted others. Loebig exercised leadership in forging collaborative relationships with other religious congregations involved in health care by solidifying joint sponsorships with the Felician sisters and with the Sisters of the Sorrowful Mother in Wisconsin. He led the second corporate restructuring, which created regional holding companies. The logo of Wheaton Franciscan Services, Inc., (below) portrays the tau cross (the signature of St. Francis, center), the open Bible (representing the gospel way of life), and the rays of the sun (reflecting God's presence in all life). (Courtesy of Wheaton Franciscan Healthcare.)

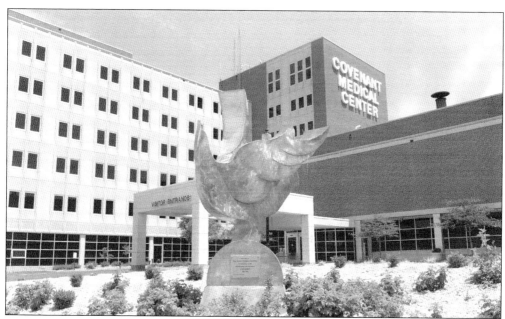

St. Francis Hospital in Waterloo, Iowa, earned the trust of the community through its high-quality service to people of the area over the years. In 1986, Schoitz Medical Center and St. Francis Hospital consolidated to form Covenant Medical Center as part of Wheaton Franciscan Services, Inc. The new facility (pictured above) provides a 511-bed acute care hospital, along with subacute and outpatient health care. The Sisters of Mercy established Mercy Hospital in 1926 in Oelwein, Iowa, and transferred sponsorship to the Wheaton Franciscans in 1982. Sartori Memorial Hospital was built in Cedar Falls, Iowa, by Joseph Sartori in memory of his wife, Theresa, a woman dedicated to community service. In 1996, it was sold to Wheaton Franciscan Services, Inc. Mercy (pictured below) and Sartori Hospitals along with Covenant Medical Center form a regional system called Wheaton Franciscan Healthcare–Iowa. (Courtesy of Wheaton Franciscan Healthcare.)

Founded in 1879, St. Joseph's Hospital is one of the region's largest and most advanced tertiary care facilities. Recognized as one of the best cardiac programs, it has state-of-the-art technologies and treatments. St. Joseph's has been known as "the baby hospital" since 1937 when it established the state's first premature baby nursery. Pictured is the St. Joseph's South Tower with obstetrical, perinatal, and pediatric units. Today St. Joseph's continues to deliver more babies than any other Wisconsin hospital. The cancer center features a shaped-beam radiosurgery that delivers a concentrated radiation with incredible accuracy. Together with All Saints, St. Joseph's Hospital, Elmbrook Memorial, Franklin, St. Francis, and the Wisconsin Heart Hospital, Wheaton Franciscan Healthcare–Southeast Wisconsin offers the region's most advanced health care system. In addition to the six hospitals, the system includes three long-term care facilities, a home health agency, multiple outpatient clinics, 2,000 employed or affiliated physicians, and more than 11,000 employees. Wheaton Franciscan Healthcare–Southeast Wisconsin is cosponsored by the Wheaton Franciscans and Felician sisters. (Courtesy of Wheaton Franciscan Healthcare.)

St. Mary's Hospital in Racine has continued to grow and thrive. In 1987, it joined with St. Luke's Memorial Hospital, an Episcopal facility, to form All Saints Healthcare. Each facility has served the people of Racine for more than 100 years. In 2006, Wheaton Franciscan Services, Inc., reorganized its health care ministries under the name of Wheaton Franciscan Healthcare. Pictured is Wheaton Franciscan Healthcare–All Saints, on the campus of St. Mary's Hospital. The state-of-the-art facility features comprehensive services such as cancer care, heart care, and women's and children's services. It is also well known for its mental health services, addiction services, and rehabilitation services. The health care at All Saints has been distinguished by top ratings from national and state organizations. It was twice awarded the Wisconsin Forward Governor's Award of Excellence, the state's highest honor for performance. (Courtesy of Wheaton Franciscan Healthcare.)

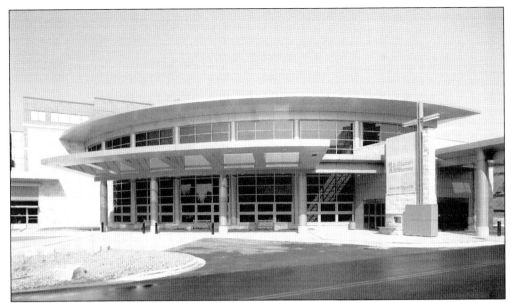

St. Elizabeth Hospital in Appleton, Wisconsin, has been a trusted health care provider for people of the Fox River valley for more than a century. From the earliest days of the Franciscan sisters' service in 1899, there has been a unique partnership between the sisters, civic community, and physicians. Funds were raised by the Franciscan sisters and the local community to build a five-story hospital in 1924. The hospital's services continued to expand in response to the growing population. St. Elizabeth Hospital has gained recognition for providing quality service, especially in the areas of cardiovascular care and cancer care. Additionally, it was the first hospital in the state to use environmentally friendly concepts of the Leadership in Energy and Environmental Design (LEED). The photographs capture the exterior (above) and interior (below) of the sun-drenched atrium completed in 2006. (Courtesy of Affinity Health Care.)

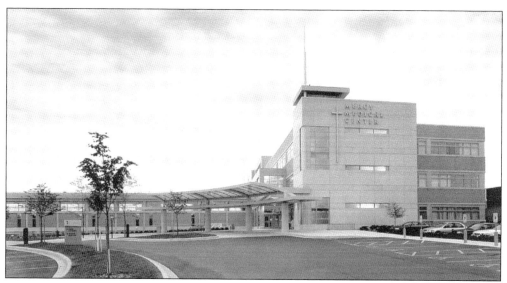

St. Mary's Hospital in Oshkosh, Wisconsin, was established under the Sisters of the Sorrowful Mother in 1891. In 1918, the sisters purchased the competing Lakeside Hospital and renamed it Mercy Hospital. The Sisters of the Sorrowful Mother opened hospitals throughout Wisconsin, Minnesota, and Iowa and later created a sponsoring organization for their health care network called Ministry Health Care. In 1995, Wheaton Franciscan Services, Inc., and Ministry Health Care partnered to cosponsor Affinity Health System, then consisting of St. Elizabeth and Mercy Hospitals. The system has since incorporated Calumet Medical Center in Chilton, shown in the photograph below. Affinity Health Care is a regional network serving 13 communities in northeast Wisconsin with 3 hospitals, 23 family practice clinics, and a managed care organization, Network Health Plan. The new Mercy Medical Center was completed in 2000 (pictured above). (Courtesy of Affinity Health Care.)

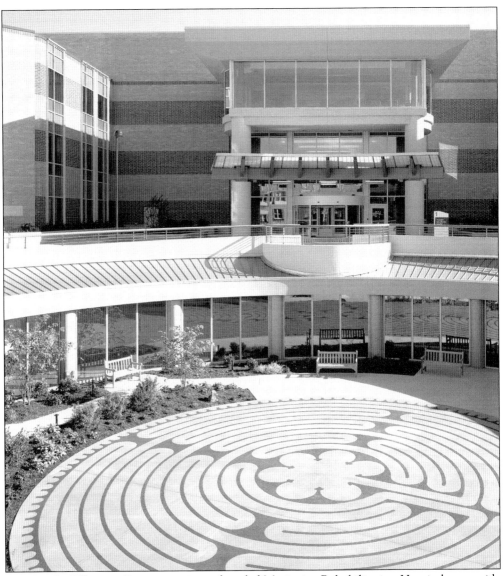

In 1972, the Wheaton Franciscan sisters founded Marianjoy Rehabilitation Hospital to provide the highest-quality physical rehabilitation services to the western suburbs of Chicago. Marianjoy's rehabilitation medicine practices are naturally holistic, taking into account the whole person as well as all aspects of an individual's lifestyle. Today Marianjoy provides a continuum of care through a network of inpatient, subacute, and outpatient facilities, as well as physician clinics. It provides individuals the opportunity to enhance their individual health, achieve their personal wellness goals, and create a balanced and fulfilling lifestyle. Marianjoy continues to offer comprehensive rehabilitation services in the treatment of stroke, brain injury, spinal cord injury, neuromuscular and musculoskeletal disorders, orthopedic conditions, and pediatric rehabilitation. In order to fulfill its mission, Marianjoy opened a new 175,000-square-foot hospital in 2006 (pictured) that offers state-of-the-art services. Marianjoy's services are delivered by compassionate clinical experts who seek to address the needs of mind, body, and spirit with one purpose in mind—helping people with disabilities achieve maximum independence. (Courtesy of Marianjoy Rehabilitation Hospital.)

John Oliverio was working for a financial firm that audited the Wheaton Franciscans and their system hospitals when he was invited to become senior vice president of finance of Wheaton Franciscan Services, Inc., in 1984. Oliverio became president and chief executive officer in 2000. He has been described as a "thoughtful, reflective, and visionary ministry leader" by the sisters who have worked with him for more than 25 years. Wheaton Franciscan Services, Inc., celebrated its 25th anniversary in September 2008. At that time, Oliverio was awarded the Benemerenti Medal. The honor was instituted by Pope Gregory XVI in 1832 and is given to individuals who have offered exceptional service to the Catholic Church and the community. The Wheaton Franciscan sisters, board members, physicians, and employees of Wheaton Franciscan Services, Inc., petitioned Pope Benedict XVI for the award. The medal was conferred by Bishop Joseph Imesch, retired bishop of the Diocese of Joliet. Oliverio is photographed after the festive mass with his medal and the framed certificate as well as symbols significant to the history of Wheaton Franciscan Services, Inc. (Courtesy of Paul Johnston.)

Sr. Rose Mary Pint (pictured on the right) served as the first chairperson of the sponsor member board in 1996. During this time, the sisters made the shift from direct control over their ministries to influencing their ministries' values and mission through sponsorship. The sponsor member board works with the Wheaton Franciscan Services, Inc., board and the leadership of the system to ensure that services and operations are faithful to the mission and values of the sisters. This translates into the organization's understanding of its Catholic roots and the commitment to live the healing ministry of Jesus while partnering with others. This 2008 photograph includes those serving on the sponsor member board and the province council gathered to celebrate the 25th anniversary of Wheaton Franciscan Services, Inc. From left to right are Sr. Sheila Kinsey, Sr. Beatrice Hernandez, Kathleen Buchman, Sr. Mary Beth Glueckstein (chairperson of board from 2003), John Oliverio, Sr. Jane Madejczyk, Sr. Patricia Norton (back), Sr. Alice Drewek, Sr. Margaret Grempka, and Sr. Rose Mary Pint. (Courtesy of Paul Johnston.)

In May 2007, the sponsor member board recommended to the provincial council the appointment of the first lay member, Kathleen Buchman (pictured). With a long history of working with lay partners, it was the beginning of a transition to a sponsorship model composed of both lay and religious leaders. Kathleen Buchman is well known to Wheaton Franciscan Services, Inc., and the sisters from her employment at Wheaton Franciscan Services, Inc., from 1986 to 2006. (Courtesy of Paul Johnston.)

Terry McGuire, senior vice president of mission services, leads the Wheaton Franciscan's Environmental Stewardship Leadership Team. The stewardship efforts are so successful that Practice Greenhealth, a national program for environmental stewardship, gave 14 awards to Wheaton Franciscan Healthcare in 2008 and planted 1,400 trees in India in the name of the system. Pictured above are (from left to right) John Oliverio, Sr. Mary Beth Glueckstein, and Terry McGuire. (Courtesy of Wheaton Franciscan Healthcare.)

The photograph above captures the courtyard of Jefferson Court, a 222-unit housing property in Milwaukee, owned and operated by FMI. FMI is a nonprofit organization committed to providing quality affordable housing for families, the elderly with low income, the frail elderly, and individuals with disabilities. Innovative management ensures responsive and cost-effective operations with a resident-focused philosophy. This philosophy is also evidenced by Srs. Maggie Ryan (center) and Theresa Langfield, at Francis Heights and Clare Gardens in Denver, Colorado. They are pictured below with James Roland at a 2007 groundbreaking for St. Francis Garden. Sister Theresa was the first director at Francis Heights, and Sister Maggie was resident services coordinator. They lived and worked at Francis Heights for more than 35 years and were active in ministries from spearheading fund-raisers to serving on boards. (Courtesy of FMI.)

Nine
INTEGRATING CONTEMPLATION AND ACTION

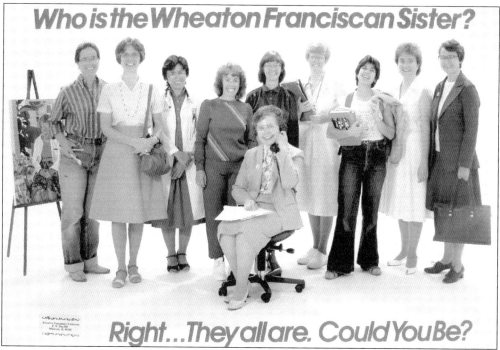

Diversity is fostered among the Wheaton Franciscans. This 1983 vocation poster portrays sisters in a variety of contemporary ministries. The poster emphasizes multiple possibilities for sisters and invites other women to contemplate religious life in a broader context. Diversity is celebrated in ministry choice and in everyday life. Wheaton Franciscans respond to both the call of God in their hearts and the call of the community in contemplative action.

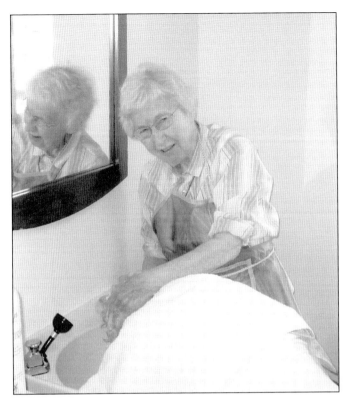

This photograph captures Sr. Mary Agnes Kloeppel shampooing the hair of one of her sisters in the hair care department at the motherhouse. The sisters attend to one another in all manner of ways, reflecting their common Franciscan values. They faithfully live as Mother Clara Pfaender advocated in the founding constitution: "Let love be the queen, the rule, the spirit and the life of the Congregation."

The sisters extend care to their employees as well. Here Sr. Mariette Kalbac (center) teaches English as a second language at the motherhouse. Sister Mariette enjoys returning to her teaching roots as a tutor for people taking the GED exam or obtaining citizenship. Sister Mariette served as provincial directress (1980–1988) during the development of the corporate system (Wheaton Franciscan Services, Inc.) and has served in pastoral care in parishes and at Marianjoy Rehabilitation Hospital. (Courtesy of Sr. Sheila Kinsey.)

Here some of the "retired" sisters who live at the Our Lady of the Angels (OLA) motherhouse are gathered for a farewell party for Sr. Alice Reckamp (front left) as she prepares to return to Brazil in 2008. Many of the sisters remain active in volunteer ministries. Pictured are, from left to right, (first row) Sr. Alice Reckamp and Sr. Carol Bosbonis (hospitality coordinator at OLA and volunteer at FMI housing); (second row) Sr. Maggie Ryan (teaches crafts at Collaborative Ministries), Sr. Pauline Langfield (liturgist, beautifier of motherhouse), Sr. Catherine Albers (volunteers at People's Resource Center), Sr. Dorothy Birk (assists in the mail room), Sr. Mary Agnes Kloeppel (assists in hair care), and Sr. Elaine Georger (eucharistic minister); (third row) Sr. Mary Patrick Salm (sacristan), Sr. Theresa Langfield (executive director of Upendo Village), Sr. Jane Petzel (assists in motherhouse libraries), Sr. Marlene Bemus (assists in health center), Sr. Maureen Elfrink (assists sisters living at OLA), Sr. Francisann MacDonald (assists in bookkeeping), Sr. Audrey Marie Rothweil (active in local parish), Sr. Timothy Scharenborg (supervisor of the sisters' dining room), and Sr. Kenneth Huelsing (assists in mail room). (Courtesy of Sr. Mariette Kalbac.)

In 1988, on the 25th anniversary of the American sisters in Santarem, Brazil, the decision was made to continue the mission work as a "region" under the general council, and the Holy Family Region was established. In this 2006 photograph, (seated from left to right) Sr. Maureen Elfrink, Sr. Alice Reckamp, and Sr. Martha Friedman pose with the Brazilian sisters who follow in their footsteps. Sister Martha, one of the original sisters to go to Brazil, organized a midwifery training program that continues today under the direction of a Brazilian sister. Sister Martha directed the novitiate program established in 1988. A Brazilian sister now manages the program. Sister Alice has been in Brazil since 1969 as a medical technologist and is the director of the aspirancy program, with the assistance of a Brazilian sister. Sister Maureen went to Brazil in 1989 and worked with sisters in temporary vows. When a Brazilian sister assumed the responsibility for the temporary professed sisters, Sister Maureen returned to the United States.

Sr. Florence Muia, an Assumption sister of Nairobi, was studying at Loyola University when she met Sr. Marge Zulaski, a Jungian analyst and provincial directress (2004–2008). Sister Florence had a dream to assist people in Kenya, her homeland, who were devastated by the HIV/AIDS pandemic. The Wheaton Franciscans were involved in HIV/AIDS ministries and desired to fight the disease on a global level. A mutual collaboration was established between the Wheaton Franciscans and Sister Florence to lay the foundation for a project in Kenya. Opening in 2003, Upendo Village provides a broad spectrum of services to people living with HIV/AIDS in Naivasha. In the photograph above, Sister Florence (left) talks with Sister Marge (center) and Sr. Beatrice Hernandez (former Upendo Village executive director and current provincial directress) in Wheaton (2008). In the photograph below, Sister Florence and Sr. Sylvia Wehlisch visit.

The Justice, Peace and Integrity of Creation (JPIC) Office promotes awareness of social justice and peace issues crucial to the Wheaton Franciscans. Under the leadership of Sr. Sheila Kinsey, the JPIC Office advocates for a consistent, broad-reaching life ethic, focusing on legislative advocacy, communication, and community involvement in areas related to poverty, sustainability, immigration, affordable housing, and the environment. Sister Sheila helped gain support from U.S. representative Judy Biggert for the Jubilee Act, a proposal to cancel the debt of third world nations. In house floor testimony, Representative Biggert attributed her insights on the issue to compassionate encouragement by Sister Sheila, among others. The sisters are pictured demonstrating their commitment to fast and pray for debt cancellation. From her base of Franciscan spirituality, Sister Sheila strives to offer input and direction in matters calling for justice, peace, and integrity on the JPIC blog. She developed the Integrity for Nonviolence program to assist with values implementation in a nonviolent environment. (Courtesy of Paul Johnston.)

Sr. Sheila Kinsey is the leader of the JPIC Office. Her tireless work on behalf of peace and justice efforts originates from a deep place of spiritual integrity. She advocates, educates, and collaborates for issues on local, state, national, and global levels. Here Sister Sheila pays a visit to Illinois state representative Peter Roskam in 2007 to discuss debt cancellation. Representative Roskam voted for the bill.

As the Joliet diocese's missions vocation director, Sr. Shirley Krull relies on personal experience when she prepares volunteers for mission work abroad. Sister Shirley served as a missionary in Zimbabwe from 1985 to 1987. Spiritual formation is a crucial element. As Sister Shirley states, "They are going to meet the body of Christ in another country." She is photographed here (center) speaking with a number of volunteers in 2008. (Courtesy of the Diocese of Joliet.)

The commitment to spiritual development for all is an outgrowth of the inner work the sisters did after Vatican II. Sr. Mary Ellen McAleese (provincial directress, 1992–2000) has designed and guided retreats, missions, and days of reflection based on holistic spirituality for more than 30 years. Sister Mary Ellen (pictured with a retreat participant) also accompanies individuals on their spiritual journey and creates personal and liturgical rituals.

Spiritual development has evolved as a current ministry of the Wheaton Franciscan sisters. They recognize the spiritual hunger in the American culture and offer both education and spiritual companionship. Here Sr. Melanie Paradis (left) and Sr. Jean Ford (center) cofacilitate a group process for spiritual directors. Both sisters were teachers for many years prior to pursuing training as spiritual directors. (Courtesy of Renata Marroum.)

The Wheaton Franciscans believe that their Franciscan spirituality offers a unique and much-needed perspective in today's world. To make this available, more than 40 vowed and covenant members share their time and talent in providing spiritual development and healing arts options through Collaborative Ministries. Collaborative Ministries was established by the Wheaton Franciscan community for the purpose of integrating "body, mind, and spirit in the lineage of St. Francis and St. Clare of Assisi." Located on the beautiful campus of the Wheaton Franciscans, Collaborative Ministries provides an environment that is conducive to spiritual deepening through program opportunities for physical, emotional, social, and spiritual nurturing and healing. More than 1,200 people from the general public participated in programs offered by Collaborative Ministries from its inception in 2005 through 2008. The programs attract women and men seeking a contemporary Franciscan perspective with an integrated approach to well being, as well as persons committed to deepening earth awareness and cultivating the sacredness of all life. This montage is taken from the Collaborative Ministries' Web site designed by Renata Marroum.

Covenant members are a rich part of Wheaton Franciscan life, and 2008 marked the 25th anniversary of covenant membership. Four women celebrated 25 years as covenant members, a nonvowed form of membership in the community: (pictured above from left to right) Carol Sejda, Laurette Kelly, Gwen Hudetz, and Rosalie Muschal-Reinhardt (not pictured). To date, 76 men and women have enjoyed covenant membership with the Wheaton Franciscans. The foundation of covenant membership is the relationship between these laypersons and the sisters. They share their spiritual journeys and their lives in mutual companionship and support. The photograph below shows sisters and covenant members who have served as coordinators for covenant membership through the years: (from left to right) covenant member Jeanne Connolly (current coordinator), Sr. Alice Drewek, covenant member Mary Krystinak, Sr. Patricia Norton, Sr. Margaret Grempka, covenant member Alice Carroll, and Sr. Marge Zulaski.

As the Wheaton Franciscans move into the future, they continue to seek out creative forms of participation and leadership. Most recently this included the intentional fostering of shared leadership. The sisters dedicated a year to learning the art of circle conversation as taught by Christina Baldwin and Ann Linnea, cofounders of Peer Spirit. The process emphasizes careful and intentional participation to listen contemplatively and to offer individual insight. As issues are raised in the circle, participants breathe through the energy of the divine center that connects each individual to the circle. This photograph shows a portion of the sisters in circle during the province chapter in 2008. The center holds a collection of symbols and images brought by participants to the circle, thus representing the whole. Through the process of chapter, new leadership is discerned and a shared direction set for the future of the province. The concept of sharing leadership by vowed and covenant members continues to energize the lives of the Wheaton Franciscans as they strive to be instruments of peace, transformation, hope, and healing. (Courtesy of Sr. Fran Glowinski.)

In October 2008, the JPIC Office coordinated an Earth Summit 2008 on the Wheaton Franciscan sisters' campus titled "Climate Change, Begin at Home." Held in collaboration with the United Nations Earth Charter Committee and other environmental organizations, it addressed climate change issues. In the spirit of St. Francis, the day started with a lively interfaith prayer service. This is a picture of the opening ceremony. (Courtesy of Paul Johnston.)

The campus was one of 50 sites around the world to host an Earth Summit. The presentations and exhibits showcased the green endeavors on the campus and in surrounding areas. More than 450 volunteers and participants from the civic community joined in the festivities. Highlights included a concert by Joyce Johnson Rouse (Earth Mama) and a Franciscan blessing of animals. Pictured, Sr. Gabriele Uhlein blesses Sr. Pat Norton's dog, Will.

The Wheaton Franciscans are aware that nature, too, is a place where all can encounter God. Their campus reflects a natural sanctuary. A "peace path" weaves through 60 acres of woodland and prairie. Walkers encounter numerous peace poles carved in the languages of those who reside and work on the campus. The poles proclaim, "May peace fill our hearts." Pictured here are Wheaton Franciscans celebrating winter's beauty. (Courtesy of Paul Johnston.)

Besides the prairies, other features of the natural sanctuary include a newly planted pine grove, a statue of St. Francis (pictured), prayer bells, a meditation cottage, and an arbor. Benches encourage a quiet pause for reflection. Here one is invited to take time to enjoy the quiet and beauty of all God's creation. May all who come to visit encounter God's goodness and blessing. All are welcome! (Courtesy of Paul Johnston.)

Bibliography

Beck, Sr. Berenice. *History of St. Clara Province*. Wheaton, IL: 1947.
Brockmann, Sr. Theodora. *History of the Franciscan Sisters of the Province of St. Clara in the United States of North America (1873–1915)*. St. Louis, MO: Herald Press, 1916.
Connolly, Jeanne. *Sponsorship of Catholic Health Care: An Adult Education Model for Preparing the Laity*. Ann Arbor, MI: UMI Dissertation Services, 2002.
Flake, Mother Aristilde. *Light into the Darkness*. DePere, WI: Independent Printing Company, 1983.
Federation of Franciscan Sisters of U.S.A. *Go to My Brethren: A Spiritual Document for Apostolic Communities of Franciscan Women*. Federation of Franciscan Sisters of U.S.A., 1969.
Klein, Sr. Rosalie, and Rita Shaker Field. *Marquette University, Nursing Education 1888–1988*. Milwaukee, WI: Marquette University, 1997.
Marshal, Dr. Victor. *Doctor, Do Tell!* Appleton, WI: C. C. Nelson Publishing Company, 1945.
Moylan, Prudence A. *Hearts Inflamed: The Wheaton Franciscan Sisters*. Wheaton, IL: 1993.
Pfaender, Mother Clara. Founding Constitution. 1860. Translated by Sr. Audrey Marie Rothweil. Wheaton, IL: 1989.
Probst, Sr. Brunilde. *The Burning Seal*. Chicago, IL: Franciscan Herald Press, 1960.
Rothweil, Sr. Audrey Marie. *The FCJM Story: The First 100 Years (1860–1960)*. Chicago: 2006.

Glossary

canon law: the legal system by which the Roman Catholic Church directs its social and pastoral activities and those of its members
chapter: the formal gathering of a religious congregation (for example, the Wheaton Franciscan Province) to set direction and elect leaders
charism: the particular grace granted by God to religious founders and their organization that distinguishes them from other organizations within the same church
covenant members: the Wheaton Franciscan term for associates to a religious congregation; these associates are laywomen and laymen, single or married, who are connected to the sisters and their mission and charism
Franciscan tradition: the historical and theological influence of St. Francis and St. Clare
general or provincial council: the directress and the councillors working together
generalate: the headquarters of the international congregation in Rome, Italy
postulant: a woman who discerns her vocation to religious life by transitioning into the congregation in order to realistically experience community living
religious life: a permanent state of life recognized by the church; religious women are often called sisters or nuns and religious men, brothers, monks, or friars
sponsorship: the canonical responsibility the religious congregation or diocese has for a ministry, including property and services

Discover Thousands of Local History Books Featuring Millions of Vintage Images

Arcadia Publishing, the leading local history publisher in the United States, is committed to making history accessible and meaningful through publishing books that celebrate and preserve the heritage of America's people and places.

Find more books like this at
www.arcadiapublishing.com

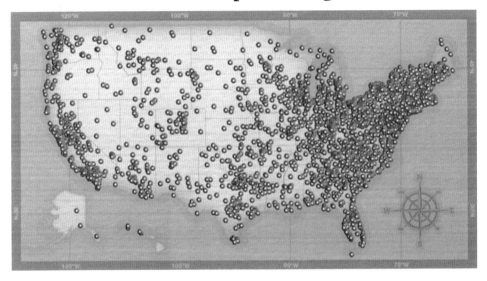

Search for your hometown history, your old stomping grounds, and even your favorite sports team.

Consistent with our mission to preserve history on a local level, this book was printed in South Carolina on American-made paper and manufactured entirely in the United States. Products carrying the accredited Forest Stewardship Council (FSC) label are printed on 100 percent FSC-certified paper.